Art Classics

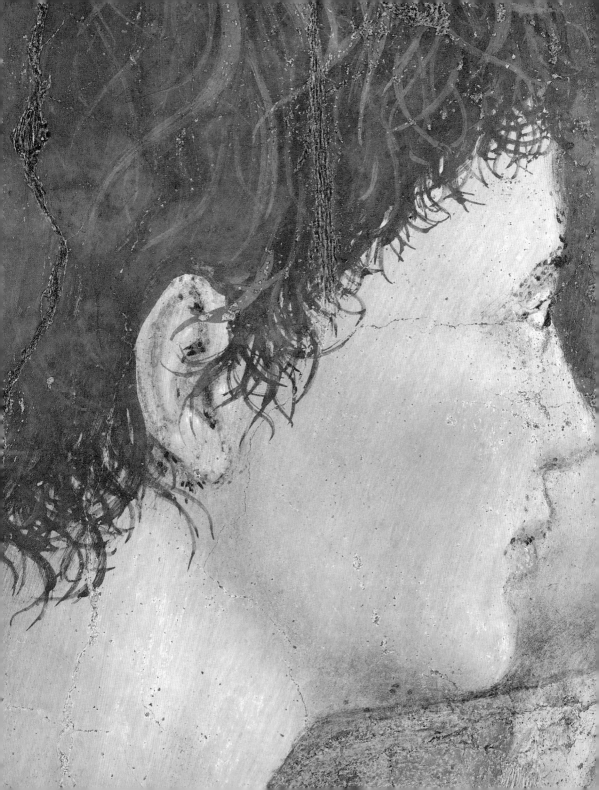

Art Classics

PIERO DELLA FRANCESCA

Preface by Oreste del Buono

RIZZOLI
NEW YORK

ART CLASSICS

PIERO DELLA FRANCESCA

First published in the United States
of America in 2006 by
Rizzoli International Publications, Inc.
300 Park Avenue South
New York, NY 10010
www.rizzoliusa.com

Originally published in Italian by
Rizzoli Libri Illustrati
© 2004 RCS Libri Spa, Milano
All rights reserved
www.rcslibri.it
First edition 2003
Rizzoli \ Skira – Corriere della Sera

2005 2006 2007 2008 2009 /
10 9 8 7 6 5 4 3 2 1

Printed in China

ISBN: 0-8478-2810-7

Library of Congress Control
Number: 2005933786

Director of the series
Eileen Romano

Design
Marcello Francone

Translation
Anne Ellis Ruzzante
(Buysschaert&Malerba)

Editing and layout
Buysschaert&Malerba, Milan

cover
*The Adoration of the Holy Wood
and the meeting of Salomon
with the Queen of Sheba*
(detail), 1425–1459
Arezzo, San Francesco

frontispiece
The Legend of the True Cross
(detail), 1452–1459
Arezzo, San Francesco

The publication of works owned by
the Soprintendenze has been made
possible by the Ministry for Cultural
Goods and Activities.

© Archivio Scala, Firenze

Contents

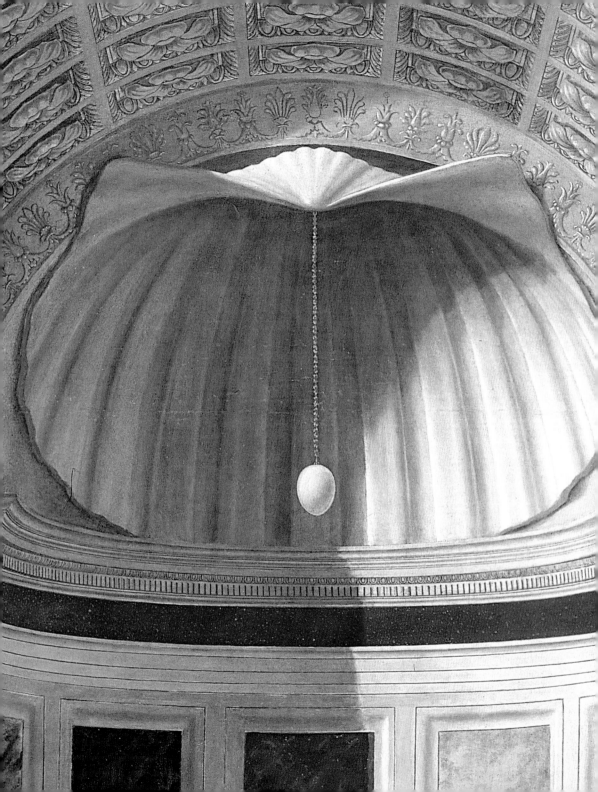

The Light of the Present
Oreste del Buono

"In order to reassure you about my well-being, I will tell you about the climate and the lay of the land and describe the villa, and I am sure it will make you as happy to hear it as it makes me to tell you […]," writes Pliny the Younger to his friend Domitius Apollinaris about his stay in the upper Tiber Valley. Winter is cold and dry, but laurel flourishes. Summer is wonderfully mild, and the air is never still, as gentle breezes, rather than strong winds, abound. In this welcoming plain ringed by mountains crowned by game-filled forests, among fertile hills where the harvest is a little late, among infinite vineyards on the shores of this river that for at least two seasons in the year is able to carry the fruits of the earth to the city, in this immense amphitheater, life resists and is as luxuriant as the laurel. Here, one may meet grandparents and great-grandparents of young adults, here it is possible to listen to the old stories and discourses of our ancestors, here it is as if time had come to a standstill, as if age did not wear men down. In this light the future is not worrisome and the past is domestic. Pliny goes on ti say, "You would take great pleasure in gazing upon this region from the hilltops: you would imagine that you are gazing, in fact, not upon a territory, but a skillfully made painting: your eyes will delight in the abundance and harmonious variety, wherever you look […]." It is difficult to be more explicit and convincing. The picture was there before the painter, who arrived one thousand three hundred years later, and to make up for it his skill will have to be truly outstanding.

Madonna with Child, Six Saints, Four Angels and Duke Federico II da Montefeltro (detail), c. 1472–1474 Milan, Pinacoteca di Brera

Piero dei Franceschi, better known as Piero della Francesca, was born in Borgo San Sepolcro [the original name of today's Sansepolcro], in the upper

7

Tiber Valley, on the border between Tuscany and Umbria, around 1420. He was the first-born child of a cobbler and tanner. As far as may be understood from old documents, his life was not filled with remarkable events. He traveled for his work, obviously, but as soon as he was able, he returned to his native land, and the records of his life, be they official or not, are almost all local. They include receipts for a few payments for commissioned works, his nomination to some public offices, a citation for fiscal arrearage, the autographed provision for the notary charged with writing his testament, and the inscription in the register of deaths; these civil and personal records the rare traces of an earthly passage attested to in a completely different manner by his works.

Curiously, the first notice we have on Piero does not come from his homeland, and this is fundamental for immediately appreciating his career. Certain documents from the Spedale of Santa Maria Nuova in Florence concerning payments to Domenico Veneziano for painting the choir at Sant'Egidio contain information. "Pietro di Benedetto from Borgo a San Sepolcro is with him [...]," informs an annotation in the margin, and the document was dated 1439. For a young man with a vocation in the arts, Florence was the city to go to for making progress, the city to go to for learning painting and science in the shade of Brunelleschi's daring dome, rising above the skies and wide enough to shelter all the people of Tuscany. "It would please me if the painter were as learned as possible in all the liberal arts, but first of all I desire that he know geometry.[...] Our instruction in which all the perfect absolute art of painting is explained will be easily understood by a geometrician, but one who is ignorant in geometry will not understand these or any other rules of painting. Therefore, I assert that it is necessary for the painter to learn geometry [...]." These new norms were proposed by Alberti in his treaty *De pictura*, which was in fact written in the years of Piero's Florentine apprenticeship. Piero became a scientist in order to be a better painter.

The great adventure that Piero begins to live in Florence involves the definitive adoption of perspective, which is an intellectual—more than technical—adventure. If we consult a recently published text by the director of the psychology laboratory at Cambridge University, Richard L. Gregory's *Eye and Brain: the Psychology of Seeing*, we read: "In art, perspective is a relatively recent acquisition. Primitive peoples and subsequent civilizations until the Italian Renaissance ignore the principals of perspective […]. It is truly surprising that Man's practice of geometric perspective, based on elementary principals, began so late, so much later than fire or the wheel, particularly if one considers that the sensation of perspective, being a part of the capacity to see, has always existed […]." Judging in hindsight is easy, arriving at perspective is less improvised and drastic, more mediated and meditated, and it is still is not clear whether one should refer to Renaissance discovery or rediscovery. It is permissible, however, to speak of Renaissance theorization: throughout classic antiquity and the Middle Ages it does not appear valid to make any distinction between viewpoint and perspective. The treaties formulate the phenomena of vision in the form of laws. Classical antiquity's laws pay with much attention to the geometric consequences, while Medieval laws focus on physical mechanisms; the problems of artistic representation nonetheless remain foreign to any kind of research. In fact, is it only with the Renaissance that a distinction begins to be made between viewpoint and perspective, and the treaties—Piero's after Alberti's—refer to the laws of vision as if to a necessary presupposition that was taken for granted at the time. Their teaching descends from Euclid; nonetheless, they aim to disseminate the rules and the procedures of artistic representation. *De prospectiva pingendi* is the title of the treaty that Piero gave Duke Federico d'Urbino. In the first of its three parts, flat figures are put into perspective, in the second, solids have their turn, and the third is devoted to human heads. The process is the same as that defined by Alberti as "legitimate construction." More than true and proper innovation, Piero adds gentle, and at times even

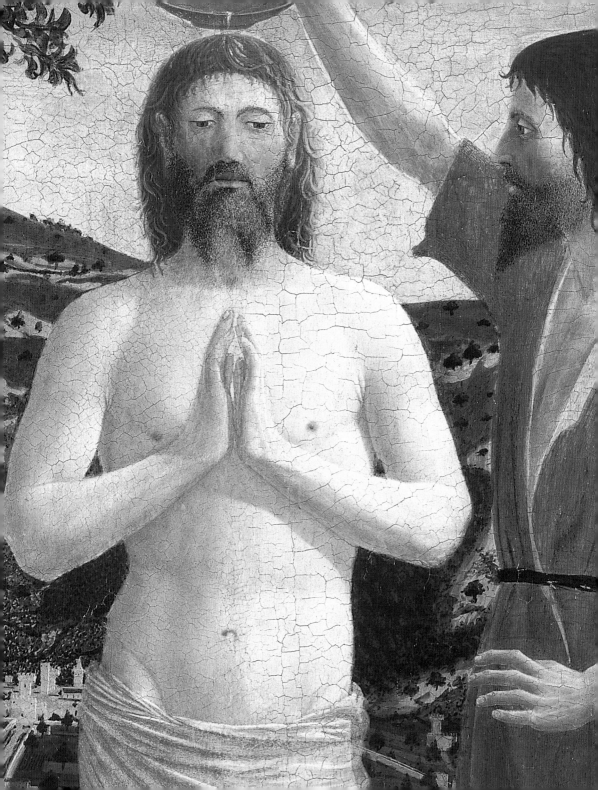

The Baptism of
Christ (detail),
c. 1450
London,
National
Gallery

emphatic, rigor. For example, he speaks of so-called marginal aberrations, declaring himself perfectly aware of the undeniable conflict between perspectival construction and the effective visual impression, and from this awareness he unhesitatingly proclaims the superiority of artistic representation. In the perspectival construction of a colonnade viewed head-on, the dimensions of the single equal elements tend to grow towards the margins, but Piero doesn't suggest just any remedy to this. "My goal is to demonstrate that it is thus and must be made in that manner [...]." Piero's choice springs forth from the richness, not the poverty, of this temperament; it is an act of faith, not an adaptation to a trend.

During his apprenticeship in Florence, Piero naturally has Masaccio's *Trinity* available to him at Santa Maria Novella: this work shows the powerful, dramatic, and spectacular pictorial application of Brunelleschi's propositions, which are the same as the architectonic and spatial relationships declared by Alberti. The master with whom Piero works is, likely not by chance, Domenico Veneziano, who is open to the possibilities and promises of perspective, and even more passionate about the beauty of color as the extreme liberty and aristocracy of painting. Masaccio, Alberti, Domenico Veneziano—Piero's artistic education certainly does not depend solely upon these names: all of Florence is a museum and laboratory, from Giotto to Fra Angelico. By mentioning Masaccio, Alberti, and Domenico Veneziano we barely scratch the surface, with the subjectivity that results from simplification of an evolutionary process towards an absolute originality, the moment when echoes, copies, and influences disappear. One learns only what one knows already, study just helps understanding, and that is all. Critics agree that the *Baptism* is one of Piero's first works. It bears testimony to how the village painter learned. The painting appears motionless in the light, and even the gesture that lends the painting its name seems to be suspended, decided once and for all, on the verge of never happening, hanging forever

11

in the inevitable pause of the act. The Baptist—with his right hand raised according to the rite's stipulations and his left hand suspended midway, his foot pointed to balance his elan, absorbed by the rest of the painting in a definitive position that is indispensable to its general equilibrium—is no more loved by the painter than the tree—with its trunk so light and leaves so dense, that flanks the submissive yet imposing Christ. Or, to be more exact, the tree is no less loved than the Baptist, which sounds different, not so much because of the mere inversion of the terms of the comparison, but because of the shift of the substance from negative to positive. The declared centrality of Christ disappears in the southern light, and the sacred nature of the painting derives not from the subject, but from the prodigy of its execution: the identification between humanity and nature, this exchange of existences that conspires in pictorial perfection. Obviously, the search for cultural references, be they admissible or inadmissible, imprecise or precise, is more than possible, but in light of the painting's completeness, erudition easily gives way to admiration. Through his masters and perspective, Piero recreated the notion that he always possessed: the landscape surrounding the baptizing peasant and the baptized savage, the appealing androgynous angels, the sculptural catechumen of the props and the cloaked Eastern doctors is that of the upper Tiber Valley. This landscape and dormantly sent Pliny the Younger into ecstasy centuries earlier, and waited for a painter. Is it the same? Let us say that it is very similar, that it communicates the same marvelous sense of harmony. It is not the recognition, nor is it the rediscovery of the familiar landscape, that counts; that would be purely fortuitous fact, whereas what counts is here Piero's awareness, and his faith in the rules for recreating that harmony. Rules are what build the world of his works, and in them appear the familiar landscape, or a gold background, or Albertian architecture; they are the rules for a harmonization of spectacle superior to all popular concerns and affirmations.

In Camus's *Noces* there is a beautiful page on Tuscan painting within a commentary on a journey to Italy. The Tuscan painter does not paint a fleeting

Madonna with Child, Six Saints, Four Angels and Duke Federico II da Montefeltro (detail), c. 1472–1474 Milan, Pinacoteca di Brera

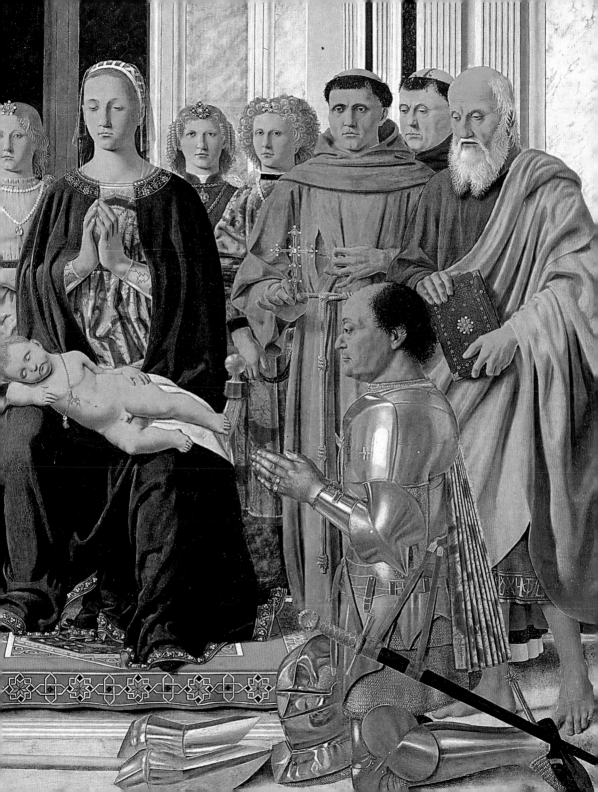

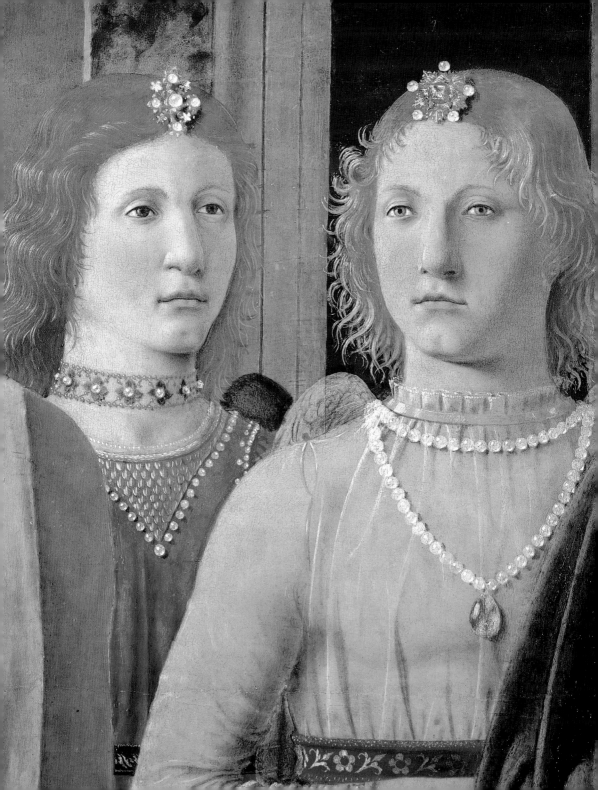

smile or ephemeral modesty, he does not paint regret or waiting, he paints protruding bones and the heat of blood. He chases the curse of the soul from these faces that come together in eternal lines. "At the cost of hope. Because the body ignores hope. It only knows the throbbing of the blood. The eternity that belongs to it is made of indifference. Like that *Flagellation* by Piero della Francesca in which, in a court covered with frescoes, the sentenced Christ and his broad executioner surprise us with the same indifference in their postures. There is no sequel to this torture, in fact. And its lesson ends at the canvas's frame. Why should we be moved by someone for whom there is no tomorrow?" This impassivity and greatness of man with no hope is truly what enlightened theologians have called Hell. "And Hell, as everyone knows, is also the sufferance of the flesh. Tuscans stop at this flesh and not at its destiny [...]." These are the days when Camus was testing the tone for his book *L'étranger* (The Stranger), and it is quite touching that one of the most acclaimed writers of our times wants to set an existentialist novel—his first existentialist novel—in the stupendous painting in Urbino. It has been said to be a suggestive passage, but, at least with regard to Piero, after perceiving a great deal of truth, it heads toward the equivocal. In the same way, the impulse Bernard Berenson comments on in his last diary, *Sunset and Twilight,* also tends toward the equivocal, even if its polemic beginning is legitimate: "A few days ago I had the fine idea to write on the general favor that pdf is enjoying at this time and to explain this popularity. I planned to cast off various intellectual snoberies that lie at the source of the compact admiration for him, which is very much due, I believe, to the need to justify an analogous cult for Cézanne [...]." This is the impulse that pushes Berenson to write his *Piero della Francesca: the Ineloquent in Art,* an elegant, fascinating discourse that gets a bit lost in the void as he attempts to address the question he considers fundamental, which, in addition to technical quality, is above all Piero's lack of sentiment. The lack of expression in his figures is impressive. "His figures are satisfied with just existing. They exist and that is all. No effort is made to explain or justify their presence, to

15

awaken the curiosity or interest of the spectator. A hundred years ago, Jacob Burckhardt, in mentioning certain altar pieces made by Bellini late in his activity, referred to them as 'Existenzbilder', paintings of existence. Today I do not dare to use this term out of fear that it may be confused with 'existentialism' or with a philosophy that I don't understand. And yet that is the way of the great figurative arts [...]." Even Berenson grasps much of the truth, but then tries to come to a conclusion that is far from it. The *Madonna and Child* in the *Brera Altarpiece*, which enchants Berenson, is no more or less painted than the *Flagellation* at Urbino, not because of any lack of sentiment on Piero's behalf, but because of his extraordinary capacity to feel, his undivided trust in the rules of painting as moral rules. It is necessary to find the middle ground between the existentialist novel and a painting of existence. The subject that Piero has chosen to paint from time to time, a flagellation or a Madonna, the celebration of a tyrant or a Resurrection, is always surpassed by the fervid transformation of science into art, an art that makes the beauty, perfection, and harmony of the creation eternal.

Five hundred years after Piero's death, Arezzo is still well protected from modern vulgarity, and the remains of ancient pride persist in at least suggesting a reference to the past. But persistence has its risks, particularly that of progressive angst shared by every illustrious fragment of Tuscan land. Persistence has its revenge as well, and the revenge of the *Legend of the True Cross*, frescoed by Piero in the choir of San Francesco, is stupendous. Once in its presence, we feel ourselves shed our sorrows of retirees of a civilization that, at times, we fear is more remote than ancient Roman or Greek civilization. Piero began to work at Arezzo, the capital of his homeland, around 1453. After his apprenticeship in Florence, he received his first appointments in Borgo San Sepolcro, but he mostly traveled and painted in Urbino at the court of Federico da Montefeltro, in Ferrara at the court of Lionello d'Este, in Rimini at that of Sigismondo Pandolfo Malatesta, all philanthropic or vile princes, renowned for their passion in regard to questions about art. The authority of

the patrons drew the attention and even the curiosity of the people of Arezzo to their fellow countryman. Arezzo is traditional when it comes to art. However, for the decoration of the chapel of San Francesco the descendants of the rich spice merchant Baccio di Magio turned not to the local representative of gothic art, Parri Spinelli, but to a mediocre Florentine, Bicci di Lorenzo, an old hand who began to fresco the *Last Judgement* in the front of the chapel and the four evangelists in the vault sails and the *Doctors of the Church* in the intrados of the triumphal arch. He was weak and slow, as if he didn't want to tire himself out before death. And death did come; Bicci di Lorenzo had painted only two of the *Doctors* before leaving the work in 1452. It became Piero's job to celebrate the legend of the True Cross, a cycle that was probably suggested by some Franciscan who knew Jacopo da Varagine's *Legenda Aurea*, as well as anti-Turk propaganda that was obviously related to the fate of Constantinople and the Roman Empire in the East. Between legendary appeal and present-day rancor, Piero nonetheless chooses, according to a rarified chronology, those few stories in which he sees the greatest visual potential.

A dying Adam orders his son Seth to ask the guardian angel for the oil of mercy that was promised to him when he left earthly paradise, but from the guardian angel he receives only three seeds to place in the mouth of his dead father. From those seeds grew the tree that was to provide the wood for the Cross. En route to visit Salomon in Jerusalem, the Queen of Sheba is suddenly struck by the revelation that the bridge over the River Siloe was made from the wood of the Cross. Thus, she kneels to adore it before crossing into the kingdom to share the revelation with the wise king. Salomon, worried about the destiny of that sacred wood, has it removed and buried deep underground to make every trace of it disappear. But everything that is fated must take place; an angel holding a palm frond announces to the Virgin the inevitable death of her son, who will be nailed to the cross. Emperor Constantine, on the eve before his confrontation with Massenzio at the Milvian bridge, dreams that an angel forces him to battle in the name of the Cross. The next day Constantine

following
pages
*The Legend of
the True Cross*,
1452–1459
Arezzo,
San Francesco

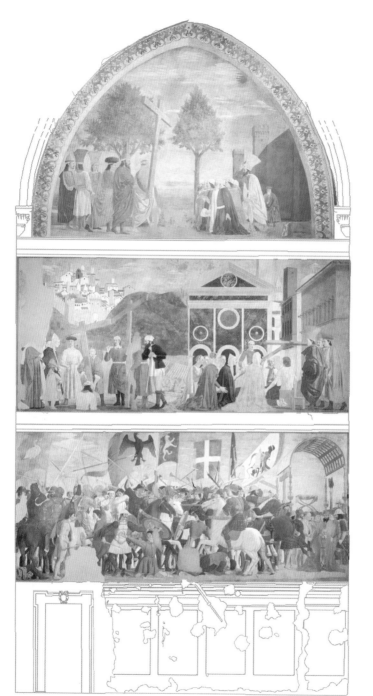
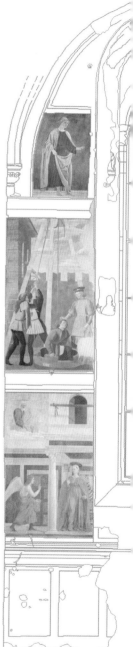

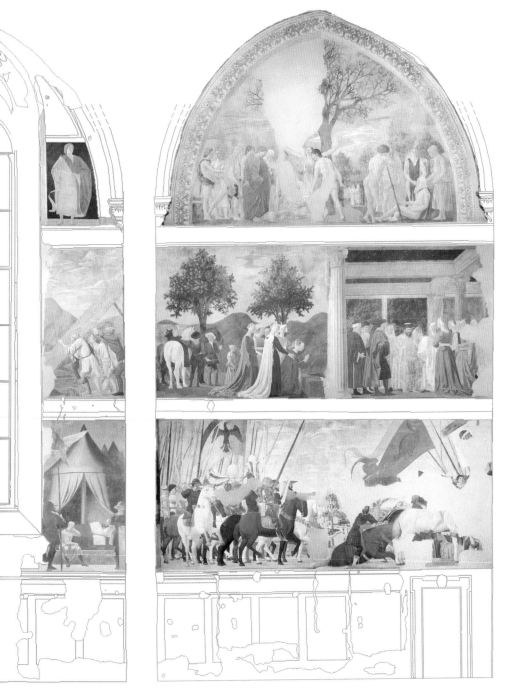

19

advances toward the enemy, clasping the little ivory Cross, at the sight of which Massenzio and his men do not even attempt to resist, but flee up the Tiber in chaos. Saint Elena searches for the cross; Judas, the Jew who knows where the Sacred wood was concealed after the death of Christ, is subjected to torture, and the judge pulls his hair to extort the secret. Judah finally confesses, and the wood of the Cross is exhumed and recognized thanks to a miracle: a dead young man is revived, a prodigy before which Saint Elena and her entourage fall onto their knees. Chosroes, the Persian king, adorned his throne with the Cross plundered in Jerusalem, but the emperor of the East, Heraclius, rises up against him, the son of Chosroes succumbs in the battle, and the Persian king awaits decapitation after refusing to convert. Heraclius returns the Cross to Jerusalem and would like to celebrate his triumph over the Persians, but the city gates are closed to him. Once humbled and stripped of any sign of his empire, bent under the heavy weight of the sacred wood, he is allowed to enter. This series of subjects, which even if they followed any slight chronology—not respected by the frescoes—might appear incoherent and arbitrary at first, but time is resolved in space. Piero's present conglobes the centuries; through chromatic assonance the coherence of images is such that out of the destruction of the deliberate narration springs forth an inebriating abduction. In the slight irradiation of colors within the arduous fabric of the story, dictated by Piero's religious rigor, lies the apparent negation of any emphasis on content and dynamism. A rustic and archaic humanity, like that borrowed from classical statues, coexists with an evolved and elegant humanity, like the one found in Renaissance courts. The great ponderous bodies of giants lend themselves easily to the role of oafs, and this awkwardness confers an even greater solemnity upon them. It is the solemnity of existing within the obedience of geometric laws that made them more alive than life itself, eternally alive, precisely understood, and precisely planned within the sovereignty of the space. Existence, the absolute present, is more important than human goals and misconceptions; the animal, vegetable, mineral existence

The Flagellation of Christ (detail), 1455–1460 Urbino, Galleria Nazionale delle Marche

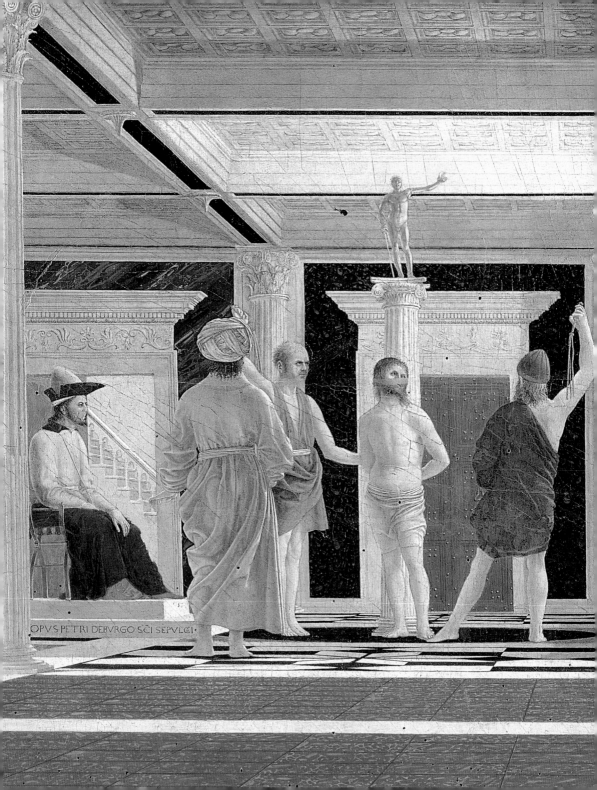

OPVS PETRI DEBVRGO SCI SEPVLCRI·

is superior to all fact atrocious or glorious, tragic or humble, devout or superb. The existence of this artistic zenith, attained through science, is very evident verification of the most abstract of theories.

Poets, from d'Annunzio in his *Città del silenzio* to Pasolini in his *Religione del mio tempo,* have exercised their pens before these frescoes. "As before a deep garden I stood, / o Pier della Francesca [...]," writes the first. "Those arms of demoniacs, those dark / backs, that chaos of green soldiers / and violet horses, and that pure / light that veils all / with powdery tones—tones of fine dust: and all is stormy—in a rage, / it is havoc [...]," says the latter. The ever moved, and often moving, poet of today, Pasolini does not resist the temptation of attributing his exacerbated passion to the village master, and he is upset at the storm and havoc, at the dramatic force of a work from which drama is banned. Certainly the sensation of the deep garden proffered by yesterday's poet d'Annunzio—who wrote many years before Roberto Longhi published his very exacting study—is more exact. But now that this name has been mentioned, it would be best to say that the greatest poetic effort concerning Piero della Francesca consists in what flowed forth from Longhi's pen: a text of true poetry in terms of both interpretations and suppositions, far more valid even autonomously, a world in itself, from the four Arezzo sonnets of the *Città del silenzio* or the Arezzo chapter of *Religione del mio tempo*: "It is impossible to go back into the choir of San Francesco in Arezzo without experiencing once again that ancient satisfaction that flowed, the first time, out of the ineffable pink of the full, light colors, as if congratulated by the light. In Piero's work, it looks as if the colors are being born for the first time as the elements of an invention of the world. In that renaissance of the visual world that truly was Tuscan painting in the first part of the quattrocento, one could in fact say that, whereas Masaccio gave us the poetic sense of an active form in plastic growth, Piero gave us the poetic sense of the color of nature that for the first time was tinged by the arrival of the first ray of a newly created sun. This is probably why its colors are elementary, as in the rainbow, or in

the vowels of a famous sonnet. But when, upon a second reading, the form also comes through clear and solemn, one understands better that those colors are 'many', they are surfaces that are measured and spread, that are complete in nature, that one leafs through from deep down under natural light. The way this calculated junction occurs through a 'perspectival synthesis' that at first encompasses a choice of simple forms in a third dimension and then returns on the two-dimensional level as a 'chromatic perspective', is, for the record, the secret to Piero's poetics."

Piero, however, was not at all concerned about protecting or hiding this secret. On the contrary, he attempts to minutely, diligently, and obstinately explain it in his treaties the *De quinque corporibus regularibus* after *De prospectiva pingendi*, which were available for perusal to all those who had better eyes than he. The great light painter spent his last years in the dark, and among old documents there is nothing more pathetic than the testimonial of one Marco di Longaro, a lantern maker. "The aforesaid Marco, when he was young, led master Piero de la Francesca, an excellent painter who had gone blind, around by the hand, that much he said to me," noted Berto degli Alberti with a smattering of suspicion, and sixty-six years had gone by since the death of Piero in Borgo San Sepolcro in 1492. In reading this rather dry annotation, it is easy to be touched by the contrasts in life. But what is truly pathetic lies above all in the words, in their unfailingly poor and emotional quality. The images that arise from this, instead, immediately gained purity: there in a cloister of Tuscan hills, led by the hand of a child, was an old man with a yet sound body, although his eyes had died. It is a subject that he would have been able to paint, and forget as he painted; he, Piero, the young guide and the man, immobile in the southern light, the irresistible light of the present that could never be corrupted nor die, the figures, like the familiar landscape, are accepted and absorbed, de-dramatized and celebrated in the harmony, solemn in the happy colors germinated between the knots of the implacable geometric consequences.

The Flagellation of Christ (detail), 1455–1460 Urbino, Galleria Nazionale delle Marche

His Life and Art

In the history of art there are men who baptized an epoch with their own art. They inform it with their own sensibility, they read it with their own intelligence, and recreate it in the invention of a new world and man. This invention may be called style, but in some cases it is more appropriate to call it revolution. Piero della Francesca is one of these men. But to avoid making what has been said become a somewhat rhetorical, solemn assumption that bears no weight and is ineffective, it would be useful to try to sketch out what the world was like before Piero, as well as what the world surrounding him was like, to fully understand his revolutionary charge.

Once his era has been understood and a general method has been accepted for approaching art questions, enabling an evaluation of art in its chronological complexity, it becomes indispensable to review Piero della Francesca's biography. This involves following the history of his training, evaluating the influence of the masters of his time, dis-covering which historical events affected him, and looking where he traveled so we may synthesize and understand his language, the expressive form that the same Piero, towards the end of his life, would attempt to fit into the theoretical framework of his writings. Thus, it is a complex operation that we are trying to accomplish. The research and scientific studies will be the core of our considerations as we attempt to explain the different standpoints that have confronted one another until now.

We shall start from the general and gradually narrow our focus to the personality of the Master of Borgo Sansepolcro. The history of painting is cyclically punctuated by moments in which what was once practice, tradition, and in some way style suddenly becomes a novelty or extraordinary interpretation. Clearly there are many examples of this, and they stretch into thousands of figurative resolutions. Wilhelm Worringer, an early twentieth-century German scholar, published a book that attempts to gather the 'biorhythms' of

on page 26
The Baptism of Christ
(detail), *c.* 1450
London, National Gallery

art history, its pulsations, its millennial cycles. In an attempt to systematize art history using the observations of earlier critics, among which we must mention here at least Alois Riegl, Worringer dilates the spatial and chronological coordinates and confronts trends, affinities, and sudden mutations. Substantially—and here it becomes truly difficult to be synthetic, although all this will be useful for what will be said later on—two periods, two trends may be identified in the history of painting that correspond to two different human behaviors that change according to the period in which they occur. Depending on whether the man, the artist, is 'serene', trusting, and recognizes himself or is fearful, timorous, and untrusting, he will view the world as something that is decipherable or obscure and incomprehensible. His mimetic reproduction is faithful to that reality, or his contrary attempt to codify or interpret it. From his view comes empathy or abstraction. The classical world, the Renaissance, and neoclassicism all express solid faith in the world and in mankind. Primitive art—Byzantine—and the great season of contemporary abstract art are the cornerstones of a psychic behavior that is clearly opposite.

We want to position Piero della Francesca's period within the history of art and his art within a precise moment among those mentioned so as to have an initial macro-parameter for interpretation. Piero's period is Humanism. Starting from the beginning of the quattrocento, this phenomenon expresses a new faith in the world, in mankind, and in man's cognitive potential. Stimulated by revival and studying the classics—both literary and artistic—the latter part of the Middle Ages see the building of the foundations for the future Renaissance. Ancient texts are rediscovered, antique statues, medals, and coins emerge out of time and the earth to build the image of a classic Greek and Latin culture that is ready flourish in all its splendor.

The reevaluation of mankind, of his physicality that is no longer inhibited by the

inconvenience of its representation because it should never be too realistic—particularly where saints, virgins or even God are concerned—becomes an obvious stimulus for research in the opposite direction, in a taste for hyper-realism that actually celebrated mankind, giving God and celestial creatures bodies and sensations taken from the masses. Popular culture became a model, through its physical drama, of tragic values. Thus there was no longer a fear of representing God as a human. A *sermo vulgaris* that becomes epic in wall paintings, in cycles that exalt the Virgin as a mother, within the tortured humanity of a crucified Christ, within the intimate mystic ascent of a saint. In reality, Humanism begins in Italian art well before its literary analogue: Arnolfo, Giotto, Nicola Pisano these 'ancient' fathers of this new sentiment of mankind, which is still primordial, are perhaps unaware, but already proudly ask God for the right to exist as a form other than divine. All the shame that makes painters fear touching God's lip with their paintbrush, drawing

Christ's rib, or the swollen belly of a pregnant Madonna, begins to disappear.

There is no will to synthesize, no graphic hint. Man confronts himself in an esthetic, narcissistic reflex that makes him search for the traits of his own dramatic physicality, of his own inalienable humanity, in the virgins, saints, and Christ the Child. This is the miracle of humanism as we see it in art: ancient art, literally rediscovered during this period, lived again in the celebration of its own myth, in the elegance of the nude in which a smooth forehead became pure thought. Mankind was believed in and his beauty was elevated to a moral, ethical canon that could even occasionally fascinate the gods on Olympus. After meeting this world and, as far as we are concerned, this art with a different and extreme conception like that barbaric one, centuries of confrontation and discussion led to an art that handled man kind and God in purely abstract terms. A shift may be seen from an empathetic value, from a feeling of nature belonging to classic

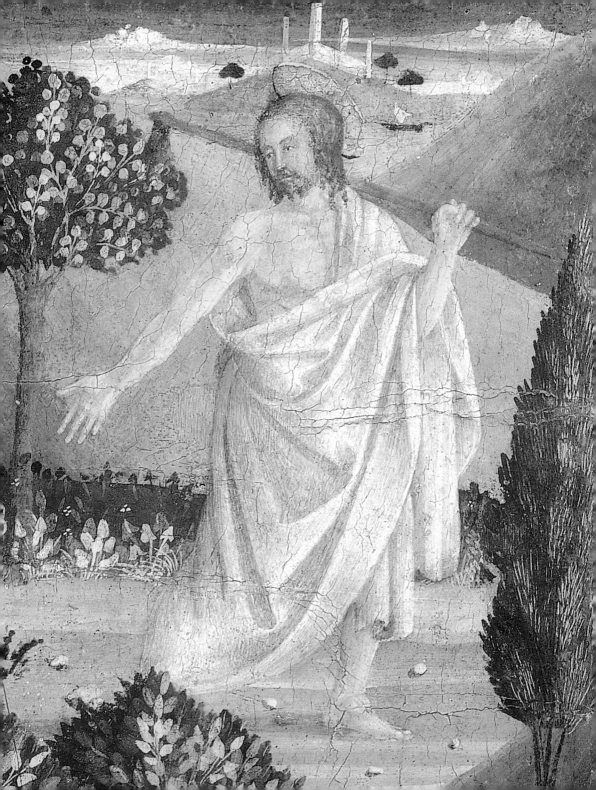

Greek and Roman art, to an abstraction, to a figurative religious discipline in which the physical is transformed into pure concept, relieved of any residue of all that is not divine, whence the hieratic figures of the early Middle Ages that populated paintings until the duecento. These icons are drawn with symbolic thoraxes and improbable flesh tones; their faces are expressionless and their ideal form is unbroken by gesture. The extreme challenge of painting in the early Middle Ages was to create a dialogue with the divine without being able to encompass it with the visual lexicon of humanity. Faces were silent, distant, set within an architectural framework that acted as a symbol, almost a metaphor of the surrounding world. Architectonic values, which were barely suggested, had neither a sky with clouds or birds traversing it nor even a landscape as their backdrop; instead it had a gold laminate that even the very modern Piero worked with in his *Polyptych of the Misericordia,* which was probably one of his first well-known works. Out of this splendid painting consisting of spirituality, synthesis, flatness, icons, and pure line balanced with color, this painting—which of course is not graphic inexperience but refined expressive code—springs the Giottesque revolution of Arnolfo and Nicola Pisano. In fact, it was sculpture that first broke away, and because of its nature it began to treat the human figure in consideration of its weight, its physicality, and with the Romanesque period it emerged out of the flat Dark Ages, declaring values that were no longer simply decorative, but proud self-celebration.

At the tail end of this shift away from synthesis, metaphor, and the symbolic toward a full sensuality of material, be it color or stone, followed the work of Giotto, who is considered by many to be the initiator of the new era. In a sense, Piero della Francesca is a successor to this because of his plastic, chromatic, and dramatic values. Piero represents the extreme opposite of a directive that begins with Giotto and continues through Masolino on to Masaccio. Giotto is

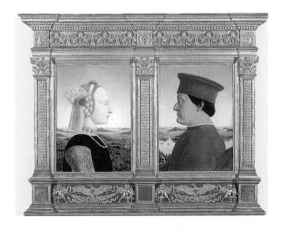

Diptych of the Duck and Duchess of Urbino,
c. 1474
Florence, Galleria degli Uffizi

about volume and drama. Masolino is about realism that is still pretty and gentle in its forms. Masaccio is about realism become drama and sobriety. Piero is an abstract synthesis of his predecessors. In some way this synthesis refers to Giotto for the dryness of its details. But all this will become clearer as we look at his works. After setting him within the feeling of trust in the world and in mankind that characterizes Classic art and Humanism and the Renaissance even more, it remains necessary to highlight a few aspects that are typical of the historic moment in which the master of Sansepolcro first made his appearance.

These aspects are not so much historic events whose influence is evidently fundamental to understanding his artistic parabola and will be discussed within the articles about the works. Rather it is a series of operative means with which Piero must come to terms and that we will attempt to cover while referring to analyses by French historian and art critic Henri Focillon.

The Legend of the True Cross
The Adoration of the Holy Wood
and Meeting of Salomon with the
Queen of Sheba (detail), 1452–1459
Arezzo, San Francesco

Among the obsessions of the Middle Ages, Henri Focillion first of all picked out the obsession with iconography, defined as an antithesis to the particular monumental style of Classical culture. The composed expressiveness of antiquity is opposed to the relentless expressiveness of medieval painting and sculpture. There is a growing influence of theatrical representations, or rather sacred representations, in painting and sculpture, in which actors and scenes with a powerfully emotional intensity, such as the Pietà or the Deposition, vivid and intense biblical scenes, are created to give rise to emotional reactions. Attention to pain and melodramatic contents may be seen in Donatello's *Magdalene* or *Madonna*. This type of art has a powerful illustrative, psychological, and emotional value that appears completely foreign to the world of Piero della Francesca. His characters, the actors in his works, express themselves in silence, with a serious, impersonal quality filled with meaning, void of apprehension in sculpted faces with broad foreheads inhabited by simple thoughts. The distance between Donatello's *Magdalene* and the *Magdalene* at the Duomo of Arezzo, which were contemporary works, was the same as that between Piero and the period he lived in. There are two opposing types of humanity, both of which are interpretable and elevated to the status of masterpieces: one that is tormented, restless, dramatic, while the other is calm, stable, weighty, generally hieratic, and thus marked by a grave and solemnly sacred sense.

The other obsession identified by the French historian is the romantic obsession. The taste for sorrow and melodramatic values becomes a demand for narrative space enriched with stories and anecdotes. Detail, and recourse to particular elements that act as detail, which is typical of many pictorial cycles, dominates two-thirds of the century, up until the point reached and imposed by the narrative sobriety, shown in the expressive minimalism of the Arezzo cycle.

The final obsession of the period of Piero

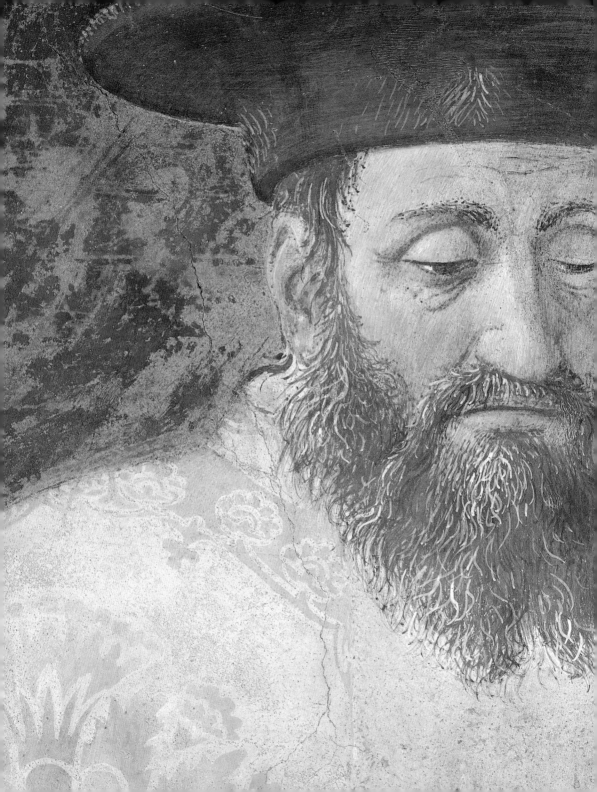

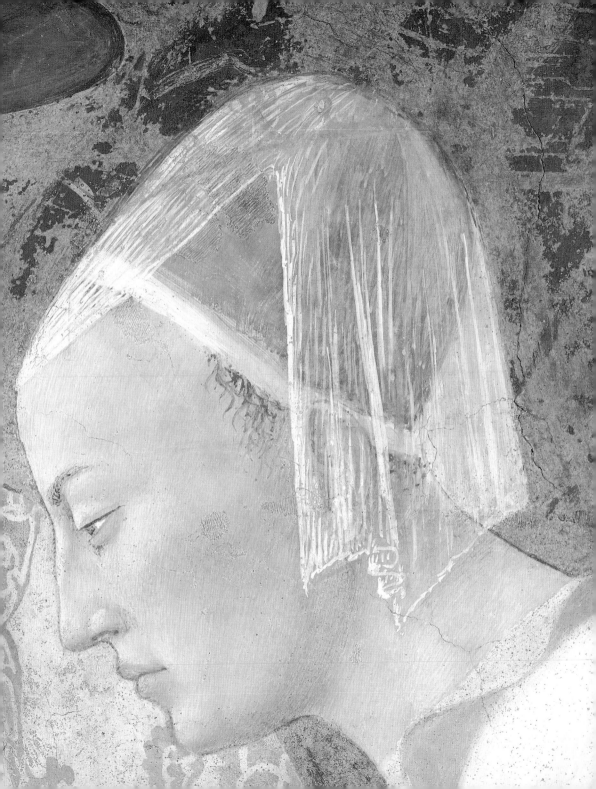

della Francesca is the picturesque, in both the treatment of the figure and the elements of the landscape. A taste for modeling with an extraordinary musical elegance was elaborated out of the picturesque, or out of the taste for the unnecessary, which was developed to create an esthetic complaisance, a feeling that is more delicate in character. Grace became one of the characteristics of many figures in works of the quattrocento and of the international Gothic style, whose courtly influence would linger for a long time. Some of these values, particularly the vibrant line, would reappear in the feverish anxiety of Botticelli's figures. Alongside this tendency towards a more graceful, slender, sinuous style that sets a pose, is a massive weightiness of Masaccio-like volumes borrowed by Piero for monolithic blocks that may be likened to twelfth-century Romanesque sculpture. These figures that speak to the intellect, not to emotion, are barely sketched out in the volume of their geometry. The same taste for the picturesque is present in the representation of nature. Picturesque and

monumental space clearly oppose one another. The image of a nature full of flowering slopes, trees, cliffs and impossible cities, typical of Sienese taste, collapses under the weight of Piero's graphic dryness, which seems to recall Giotto's absoluteness, but with a clearly more modern understanding of perspective and space. Nature "is not a dream but a space adapted to the spirit. An essential and luxuriant tree replaces the forest so dear to his friend Paolo Uccello," writes Focillon.

Thus, in conclusion, Piero della Francesca —with respect to the figurative culture that surrounded him, and we shall try to trace the directives right from the Sienese influence— was, in some respects an outsider. He pursued only what involved the more sculptural directive, from Giotto to Masaccio, leading it to an essentiality that became a stylistic signature of all his work. We shall attempt to identify the traits that his art borrowed from what his predecessors and contemporaries had to offer. But to do this, it is necessary to reconstruct the fundamental lines of a precise

historic moment, identifying the master within the cyclic quality of art history, and its biorhythms within the dialogue between the abstract and empathetic poles. Furthermore, it is necessary, as already mentioned, to set his work within the context of the immediate requirements of his era's culture.

Positioned somewhere between empathy and abstraction, between mimesis of reality and intellectual transfiguration, Piero della Francesca moves within the humanism of his era with a very characteristic abstract ability that no longer appears generated by fear and misunderstanding. Instead, it is generated by opposing motives: a love for mankind, its mathematical proportions, its compositional purity, becomes sobriety, monumentality, an ideal universe, and at the same time humanism.

There is little absolutely certain information about the life of Piero. The story of his life comes down to us through the strength of his works, at least those that still exist. The rest is biography. Be-fore telling his story, it can be useful to know how his works were judged over the centuries. Because this too can explain the shortage of information available for creating a biogra-phy. In the quattrocento, his fame was not yet widespread. His works were starting to guar-antee him new important commissions, but not yet fame. His name is often mentioned in works by researchers and architects. One of his students, Luca Pacioli, a mathematician known for, among other things, his book en-titled *De divina proportione,* published in 1509 and illustrated by Leonardo da Vinci, men-tions Piero with much praise. Piero also ap-pears in the commentaries of Vitruvius and is cited by all the major sixteenth-century ar-chitects. The chroniclers mention him in a va-riety of ways. Among them, Vasari speaks of Piero as if he knew him personally and had been able to appreciate his work directly. Nonetheless, there is little biographical in-formation, and Vasari persists in his esteem of Piero's genius, which is nonetheless underes-timated. Among other major evidence, we

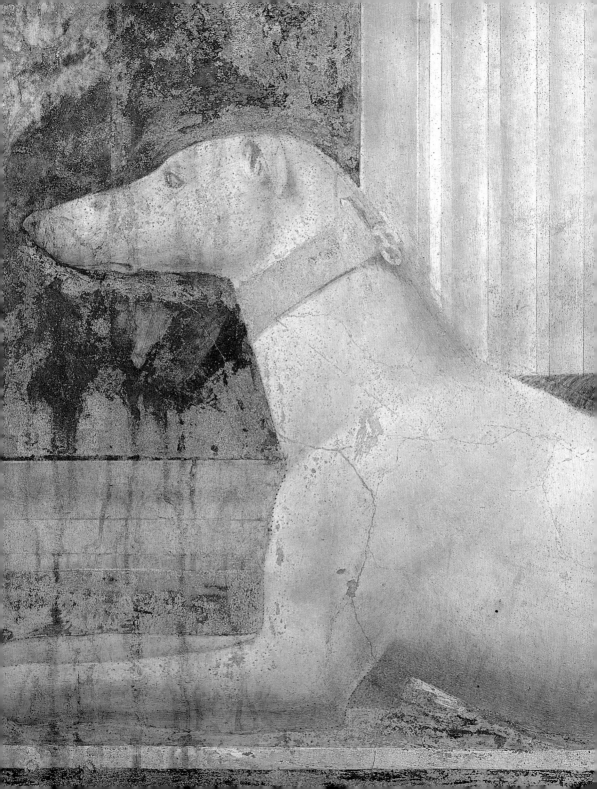

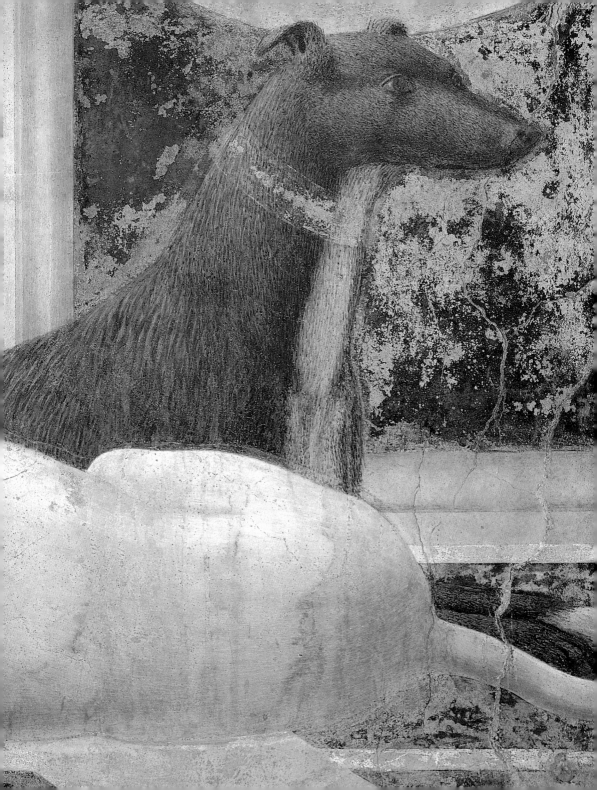

must remember bits that from the end of the seicento were continued through at the early ottocento by the hands of Joachim von Sandrart, Giovan Pietro Bellori, Giovanni Pascoli, Filippo Baldinucci, Luigi Lanzi, and others to Pietro Zani's encyclopedia finally be printed in 1804. 1868 marks a time for re-evaluation, with Stendhal's treatment of him in his history of painting in which he makes a few points—such as his affinities with Paolo Uccello—that were taken up by later critics. Once again, however, the value judgement is partial. Still, in terms of citations, the master is present in a fundamental work such as Jacob Burckhardt's *Cicero*. The first true discovery, at least on a historical level, occurs in a book by Giovanni Battista Cavalcaselle and Joseph Archer Crowe on the history of Italian painting published in 1864. The first to take an interest in him with any critical shrewdness was Bernard Berenson. With him we must also cite the fundamental considerations of Roberto Longhi. Longhi was probably the first to recount, in 1927, with critical

acumen, a wealth of documentation, and a pleasant style, the artistic parable of one of the masters of the first Renaissance who was the most important in the entire history of Italian art. More recent comparisons and studies shall be discussed in the bibliography for further study, while we will refer to different explanatory positions and keys at different stages in the text. This brief digression about Piero della Francesca's fortune over the centuries is necessary in order to somehow explain the almost unobtrusive, solitary appearance of an extraordinarily high period in the history of Italian art and the aura of mystery and perplexity that grew up around his works, and consequently around his person. And this leads us to his story…

Piero was born around 1420 in Borgo Sansepolcro to Benedetto de' Franceschi, a wholesale leather merchant. His full name is Piero di Benedetto de' Franceschi, but since Vasari he is known as Piero della Francesca. The same Piero does not use this

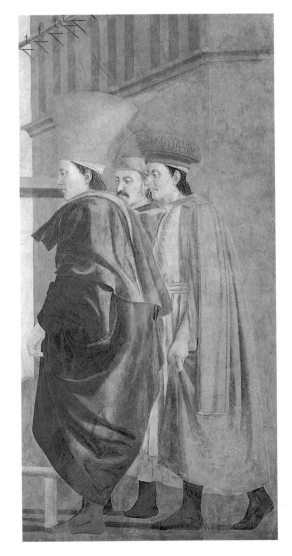

name to sign his works, but goes down in history as 'Petrus de Burgo'. The explanation of 'della Francesca' comes from the wife of his grandfather, Piero, Benedetto's father, who was called 'della Francesca' to distinguish him from two other Benedettos that lived in Borgo Sansepolcro at the same time.

To complete the genealogy of the family, we should remember that he had two brothers, Marco and Antonio, while two others, Luigi and Matteo, died as children. He also had a sister, Angelica, who was married before 1454. The family genealogy now established, it needs to be positioned within Borgo Sansepolcro, a crossroads of commercial traffic between Tuscany, Umbria, the Marches, Emilia, and Latium. These commercial routes allow us to imagine a hypothetical geography of the painter's travels, which were often documented by archival sources. The development of every painter, and the geography of his travels, are a legacy of information fundamental to understanding his training, his stylistic variations, and identifying new influences on

him that are extraneous to the figurative tradition in his native town. Borgo Sansepolcro is where his training began and to which Piero's destiny is tied at least until 1438. Thus, this is where we should begin.

In Borgo Sansepolcro, in the domain of the Malatesta family, who were lords of Rimini, Papal dominion began in 1430. As has been said, in the Borgo, an important crossroads for traffic and commerce, a series of evolutions was taking place at this time. It is the young Piero, a painting apprentice of Antonio di Giovanni d'Anghiari, who prepares the changes for the new lordship. D'Anghiari was likely Piero's first master, although no works from his activity remain that would allow us to evaluate his style or manner, despite the fact that he was fairly well documented between Anghiari and Sansepolcro. The two artists worked together to paint the coat of arms of Pope Eugene IV (1431–1447) on the city gates. Documents suggest they were also involved in creating banners. These first contacts of Piero's with

painting took place within a sort of 'heraldic initiation' that seems to influence the constitution of Piero's painterly world. If we consider the cycle of the *Legend of the True Cross* of Arezzo, and the battles in the two lower registers in particular, the standards, in their chromatic pride blown straight by the wind, suggest the influence of such an experience in his youth. This would continues to influence all his later painting. The coat of arms drives narrative and descriptive values back to their extreme formal, geometric synthesis. Pure relationships of color and line define more or less complex meanings. To create a coat of arms one must be an extremely synthetic painter. It would appear that Antonio d'Anghiari was a master, a specialist in this type of composition. But, once again, we are unable to discuss his painting today. Still, we know, and with this we return Antonio to the anonymity of the times, that the opportunity of a lifetime—the altarpiece for the high altar of the church of San Francesco at Borgo Sansepolcro, commissioned from him in

44

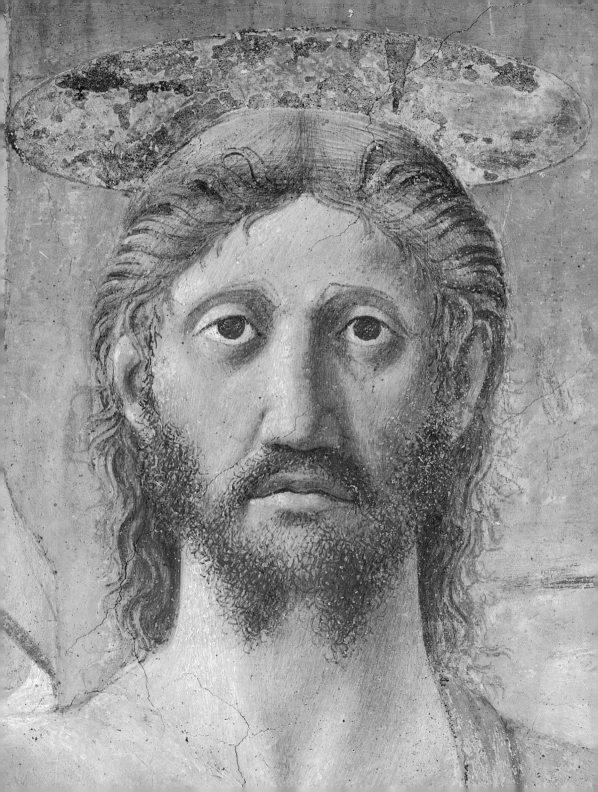

1430—was taken away from him in 1437. Its execution was entrusted to Sassetta, the Sienese artist whom we will discuss later on. Antonio then abandoned Borgo Sansepolcro in search of greater fortune in Arezzo.

Of Piero's first years in the Tuscan Borgo we must also outline his mathematical studies confirmed by Vasari: "involved in mathematics in his youth, when he was fifteen he already showed an inclination towards painting, but never lost interest in mathematics." His mathematical studies offered a basis for all of Piero's painterly discipline. The theories he produced in his treaties, including *De abaco,* which is very likely the first one published, would guide his research in a careful mathematical evaluation not only of proportions and perspective, but sometimes even of the sentiment studied in precise poses, in highly meditated emotive mechanisms. Each pose is studied, each relationship of form is calculated. His first years of life were thus spent applying gesso to canvases, drawing banners, and doing mathematics in the form of accounting exercises, which would be useful to him not only for theoretical considerations, but also for his work as an artist and in doing the family accounts. Piero is, in fact, one of the few Renaissance artists to be backed by a solid economic situation consisting of diversified land and interests including the production and commerce of *guado,* or woad, an herb that was processed to obtain indigo for dying cloth. Familiarity with color appears in his paintings in the solid, geometric, mathematical coloring of the clothing in which he dressed his figures.

These are the first prerequisites in his native city that, after the period under the papacy, was ceded to the Florentines to become a major center and obligatory route for goods travelling up the Apennines to the ports of the Adriatic from Tuscany and the Tyrrhenian Sea. Thus, with the period under Malatesta rule, the following papacy, and finally the Florentine dominion, the city, with its population of four thousand, developed a significant role for itself in the political equilibrium of the time. This translated into a political class that could carry

on a dialogue—when it did not even have its own representatives there—with the most powerful political and cultural centers. According to documentary evidence many citizens of Sansepolcro appear to have held important positions in Rimini and Rome, allowing researchers to make suppositions as to why Piero traveled to these cities. Nonetheless, the first trip he made to Florence was certainly in 1439.

In that year, the council leading to the confrontation between the Christian East and West regarding the Holy Trinity was held in Florence. The representatives of the Greek world paraded down the streets with a whole series of suggestions, costumes, and colors that were variously interpreted by the artists working there in that period. Among these were Domenico Veneziano with his assistant Piero della Francesca. We know this from a document referring to payments requited to Domenico for the frescos at the church of Sant'Egidio. Documenting the council are some drawings

by Pisanello that attest to a general interest in that particular historical event. His sketches recount a series of influences, and attention must be drawn to hair dressed in a Near Eastern manner, which would appear frequently in Piero's painting. Pisanello is intent on gathering information that would result in the medal dedicated by the artist to Emperor Giovannin Paleologo, joined by his followers, for the final acts of the council. Thus, at Florence, in addition to working with Domenico Veneziano, Piero came into contact with a figurative culture that in those years involved Pisanello, Fra Angelico, Masolino, Masaccio, Filippo Lippi, and Paolo Uccello. The first and second generations of the Italian Renaissance, with all their stylistic and technical variations, confronted one another before the eyes of an adolescent ready to absorb all its revolutionary strength, so distant from that Sienese culture that would have informed his first works. On both a formal and iconographic level, Piero absorbed a graphic culture in Florence that challenged tradition in its interpretation of the new role of mankind in

the world and in art, and created a painterly humanism of which he is one of the most sober and complete expressions. He also admired influences from antiquity, of a classic world rediscovered and proudly exhibited in collections and leaflets for artists to use. Given the high probability of a more than stylistic encounter between Piero and Pisanello, and considering the latter's practice reproducing antique vestiges as a mental note, it is easy to explain the syntheses that the painter offers of these influences in works such as the *Baptism* or the *Flagellation.* Thus, during his stay in Florence in 1439, Piero had a variety of experiences that were significant to his training; foremost was his apprenticeship with Domenico Veneziano, which is documented.

Thus, the first figure with a strong esthetic personality to influence the work of the Master of Borgo Sansepolcro was Domenico Veneziano (ca. 1410–1461), about whom there is little information. His Venetian origin is known, as is as the influence Gentile da Fabriano had on him. He was also active in Perugia, where he was involved in painting a room in the house of Baglioni, perhaps with the young Piero. The frescoes in question were unfortunately lost, however, and we therefore may only hypothesize about Piero's initial training in Umbria rather than Florence. Domenico Veneziano is a painter who brought Gentile's courtly elegance to Florence, where he nonetheless sacrificed it to Florentine Renaissance values. The Gothic matrix clearly remains perceptible in works such as the tondo depicting the *Adoration of the Magi*, conserved at the Staatliche Museen in Berlin, despite restoration, particularly in the treatment of the figures. The other work that is useful to read with regard to the master's influence on Piero's work is one that is considered Veneziano's masterpiece: the *Altarpiece of Saint Lucia de' Magnoli* made around the mid-1440s and today in Florence's Uffizi. The first works cited show Piero's distance from his master's Gothic residue, and they also suggest some compositional affinities—

The Legend of the True Cross
Constantine's Dream(detail),
1452–1459
Arezzo, San Francesco

the procession of the Magi is not so different from that of the *Queen of Sheba* in the Arezzo frescoes. The second work, meanwhile, shows the most important lesson Domenico gave his student: luminous, bright, concise painting that builds figures in the light. The Uffizi altarpiece is a fully Renaissance painting in its architectonic framing that abandons the usual polyptych subdivision by setting the figures within a drawn structure. The perspectival foreshortening of the brick, the colonnade, and the shell framing the face of the Madonna are all elements that have a clear compositional affinity with Piero's works. But, above all, what is striking and will be pushed to its most extreme values is the use of light. It is a diffused light that comes from the chromatic blending of colors which are not juxtaposed, rather harmoniously integrated in to the drawing. Nonetheless, the Child held in the Virgin's arms is at least one era away from those painted by Piero della Francesca, in the elegant, musical, almost mannerist torsion of the body that is absent from the geometric seriousness of Piero della

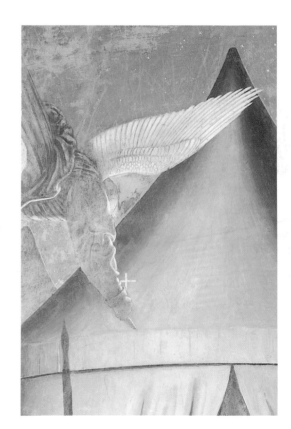

Francesca's homologues. The void and the whiteness of works such as the *Martyrdom of Saint Lucia* in the section of the altarpiece conserved at Cambridge, become the dawnlike essentiality of Piero's painting. He uses the evocative and suggestive power of the figures, exemplified in works such as *Saint Sigismondo Pandolfo Malatesta,* in which he uses the same limpid visual vacuity. The influence of another Renaissance protagonist, Fra Angelico, has the same lineage. Piero's interest in the friar's painting, particularly in the frescoed walls at the convent of San Marco in Florence, must have been very powerful, even voracious, as he attempted to understand the secret of the clean-cut volumes marked by the precision of subtle contours and immersed in clear and transparent atmospheres with an extraordinary and delicate narrative capacity. Piero understood the mystery of the use of light from both masters and transformed it into poetry in his own compositions, and at the end of his Florentine apprenticeship Piero was ready to take on his first masterpieces.

Piero returned to Borgo Sansepolcro in 1442 among those citizens who were eligible to become members of the municipal magistrate. In 1437, right in the city that had recently become Florentine—Eugenio IV was, in fact, forced to cede it to Florentine control because of debts from the counsel of 1439—the commission of the altarpiece for the church of San Francesco was entrusted to Sassetta. The work was completed in 1444, one year before Piero received his commission for the *Polyptych of the Misericordia*. The presence of one of the most important artists from the Sienese school of the period just prior to Piero's official debut in art history makes a few considerations regarding the eventual traces of his work's Sienese qualities timely, particularly considering the fact that the work made at Borgo by Sassetta, the *Apotheosis of Saint Francis*, was also his true masterpiece.

Stefano di Giovanni, known as il Sassetta, was born in 1392 at Asciano and began to work at Siena around 1423. He moved

The Legend of the True Cross
The Adoration of the Holy Cross and
the Meeting of Salomon with the
Queen of Sheba (detail), 1452–1459
Arezzo, San Francesco

primarily in the realm of Sienese patronage and in 1427 he also tried to work on a project for the duomo, but was not accepted by the patrons. Between 1430 and 1432 he painted the *Polyptych of the Madonna of the Snow,* and in 1436 completed one of his most noted works, the great *Triptych of the Osservanza.* His painting is tied to the values of the international style that likened him to Gentile da Fabriano, Masolino, and Pisanello. In this painting, forms are convulsed, tormented, not modern. This style is quite distant from Piero's powerful grace and volume. In the figure of the saint in the altarpiece of San Francesco, Longhi detects a substantial fullness and a physicality that is found in Piero's works as well. But the latter does not play so much with the volume as with the treatment of the balanced, modern, harmonious features. That Piero was familiar with Sassetto's work appears indisputable: he was in his city, working on the most important pictorial—and thus most visible—work of the moment.

A painter endowed with a spirit of analysis the way Piero was had to have contemplated the lesson of the Sienese master. But it is also true, and almost amazing, how differently they handled volume. Piero's essentiality moves within a space that in Sassetto's work is only able to accommodate the compositional schemes, which, furthermore, were imposed by the patron, such as the gold background. Beyond every type of geometry, what distinguishes and distances Piero from Siena is something thoroughly graphic and monumental from his first, serenely geometric, serious, courtly, immobile experiments. Piero may have been influenced by that atmosphere which was all gold and elegance, but once again he sheds it with all his modernity, barely hinting at it in his *Polyptych of the Misericordia.* The figures he drew appear embarrassed by the vastness of the gold in which they stet immersed. They appear to be stolen straight out of Renaissance architecture and placed there to fill the space left by some icon out of the duecento. They are enchanting within that gold, but they also seem like a strident figurative anachronism.

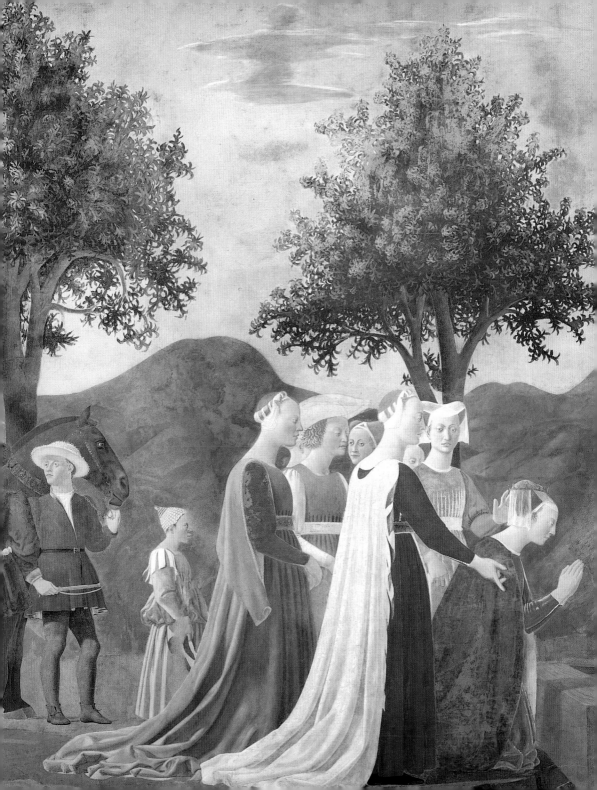

Before continuing along the master's trail, life, and works, it is necessary to stop and look at other figures who were fundamental to the art of Piero della Francesca: Pisanello and Paolo Uccello. These artists were fundamental because of the influence they had on the construction of a space that is not mere architecture or a citation of it. Rather, it is an organized representation of spatial values inhabited by man.

The first, Vittore Pisano, known as Pisanello, was born in the last years of the fourteenth century. Of Pisan origin, he spent his youth in Verona. We know little about him and equally little about his life. The frescoes in the churches of San Fermo and Santa Anastasia, a few drawings, a portrait of Ginevra d'Este, and a few other works remain. A series of medals in a style borrowed from antiquity testify to his love for classic art that conveyed compositional models and modalities gathered from many other painters of the epoch. He belonged to the first rank of Renaissance painters, together with Masolino and Fra Angelico, and he is still tied to the rules of international Gothic, and thus a love for detail and exiled, vibrant forms in his treatment of figures. Pisanello is renowned primarily as the skilful author of noble profiles. In addition, he is known for his horses reproduced in their physical, geometric strength, which began a tradition. The taste for detail is still Gothic in his work, as are the architectural frameworks for his scenes. The forests and the backdrops are filled with animals and a variety of plant species in an alphabet of wonder out of which emerges the figure of mankind. Midway between the culture of the North, of the Giottesque artists working there, and the Tuscan lesson, Pisanello becomes tied to Piero for the portraits of the Este family, in which a curve indicates an emotion, with all the strength of chiaroscuro, leaving a spot of fleshtone spread compactly over the black background.

The *Portrait of Emperor Sigismondo*, from the 1430s, represents an immediate reference to *Saint Sigismondo and Sigismondo Pandolfo Malatesta* of Rimini. The human figure is

thought of and studied according to rules and correspondences that enter into Piero's construction of form as the compositional skeleton that the Master of Borgo Sansepolcro would invest with the weight of his geometry and volumes.

In addition to profile, which, as Pisanello points out, is the authentic expression of an individual's originality—and Piero would later be measured by that same originality in the double portrait of the Duke and Duchess of Urbino—the Pisan is also the initiator of that solid animal nature that is either foreshortened or presented from behind. In the *Departure of Saint George*, the foreshortening of the horses is nothing but an attempt to create a space for the depth of the planes. From Pisanello, whom he certainly had the opportunity to know in Florence, Piero borrowed the graphic purity of the profile. There are many examples of this in the cycle of the *Legend of the True Cross* in Arezzo, and in the taste for space developed through the corporeality of the animals and the foreshortening of their bodies.

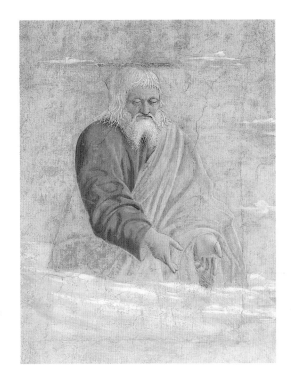

The Legend of the True Cross
The Battle of Constantine and
Massenzio (detail), 1452–1459
Arezzo, San Francesco

While Pisanello belongs to a culture that precedes that of Piero, Paolo Uccello (1307–1475) is his contemporary, and expresses that culture's yearning for geometric rationality that becomes almost an obsession for him. His painting follows that of Pisanello, but is influenced by Alberti's theory. His paintings are the result of a theoretical consideration of the practice of painting and of a discipline in the construction of forms within the space that is Renaissance in style. In Uccello's works as well, to further outline Piero's modernity, Gothic elements linger on even in his most famous works, such as *The Battle of Saint Romano* (1435–1440), *Saint George and the Dragon* (c. 1456), and the *Hunt by Night* (1460). Here a Gothic-infused vegetation consisting of a variety of plant species constitutes the dark backdrop of the painting. The figures that move before these scenes are geometric constructions that in turn create the space. *The Battle of Saint Romano* is clearly the work that lends itself best to a comparison with Piero's painting.

The references are *The Battle of Constantine and Massenzio* and *The Battle between Heraclius and Chosroe* in the Arezzo cycle, which may be dated to 1452–1459. In Uccello's work, the lances fallen to the ground create a checkerboard that is the expressive instrument of an obvious desire to create perspective. In Piero's work, the agitation of Uccello's movement acquires an epic, placid value. It makes references to Roman sarcophagi and to the demand to create a tangle of bodies that recounts the drama and fatigue of the battle in an organic whole where each figure plays a role in a precise balance. In the *Battle between Heraclius and Chosroe* a flatness prevails that only the architecture on the right of the work attempts to elude. The entire fresco is a mass of luminous color, a display of standards, a *dignitas*, read on the Roman ruins. Once again it is sculpture that creates Piero's pictorial values. Paolo Uccello defines his own idea of perspective with the help of looming rock walls that push the battle into the spectator's plane. Once again, Piero

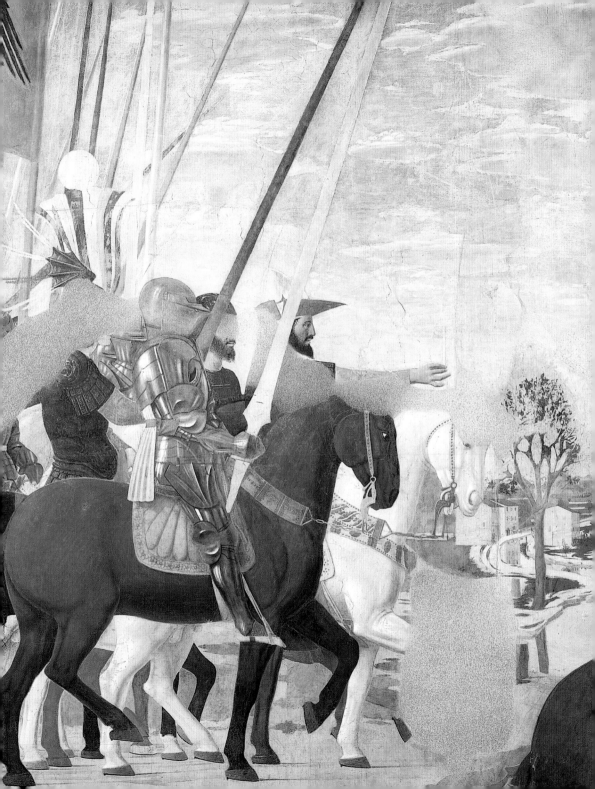

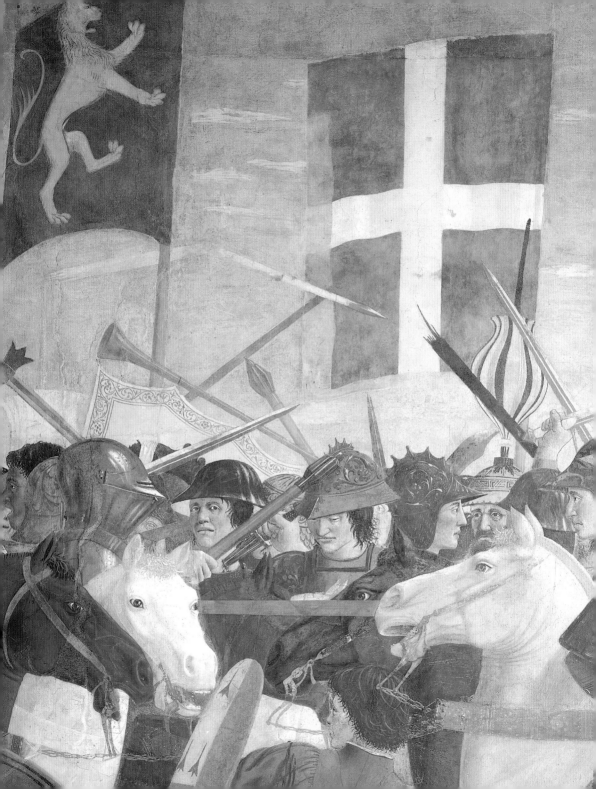

The Legend of the True Cross
The Battle of Heraclius and
Chosroes (detail), 1452–1459
Arezzo, San Francesco

uses the vagueness of the void, in which he substitutes the gold with an extremely blue sky. The horses are re-elaborations of Pisanello's and Uccello's first attempts at perspective. Here everything leads back to classical, Roman dignity, to an elegant frieze. Certainly the vision of the painter's oldest work in Santa Croce in Florence, *The Equestrian Monument of Giovanni Acuto*, painted in 1436, must have influenced Veneziano's young student's sculptural awareness. In the end, the monochromy used to portray a man on a horse is simply an attempt to use painting to sculptural effect. Herein lies the lesson Uccello offers Piero: painting becomes sculpture, which loves monochromy, because its chiaroscuro values construct the figure in its pure essentiality. To this tension, to this geometrical attempt to situate objects in space, Piero adds Veneziano's luminosity and a highly personal compositional synthesis. Longhi writes: "Imagine Paolo Uccello's forms smoothed over and delightful colors transported into a monumental and solemn stairway and suppress the residues of Gothic intonations of nocturnal fable that were still present in Paolo Uccello's works; then give every surface the daylight of Domenico Veneziano, but with a lighter, more meridian, more *plein-air* rendering, and you get Piero dei Franceschi."

In order to appreciate Piero's art, it is enough to just enjoy his simple vision, because his suggestive power is so strong. To understand it, on the other hand, it is necessary confront his time period and the protagonists who lived in it as we have mentioned. Il Sassetta, Pisanello, Domenico Veneziano, and Paolo Uccello are the prime influences for the young man. An attempt has been made to follow the fundamental veins of inheritance that transformed themselves as they traversed Piero's painting. Other influences that we will go into later on are those of Dutch painting and the work of Leon Battista Alberti. First it is necessary to return to Piero's travels through the courts of Italy, so as to gather a few indications that will be useful in defining

his art, and above all to begin rejecting all the observations made until now in the study and analyses of his masterpieces.

We left Piero della Francesca painting the *Polyptych of the Misericordia* in the mid 1440s. The work, which kept him busy until 1462, is an immediate index of the revolutionary strength of his painting. Immersed in a gold background with a thirteenth to fourteenth-century flavor to it, he drew faces, poses, and clothing in an extremely modern manner. His beginnings had already betrayed that geometric, plastic construction consisting of heavy volumes that would mark the painter's entire career. Thus, it was a style that appears extremely decisive, aware, and characteristic right from the beginning. Over time this style would be enriched with different experiences, but right from the start it declared its compositional force and its metaphysical suggestion. The importance of the *Polyptych of the Misericordia* is that it heralds a new kind

of painting belonging to that family of artists already mentioned that worshipped Giottesque volumes. The figures in the *Polyptych* are solid intellectual sculptures in which Piero immediately exercised his mathematical skills. To this effort to return nature to its geometric essence, without ever losing balance, may be added the steps toward an esthetic education, every moment of which is reflected in his works. One of these fundamental moments was his experience at the court of Urbino. In the 1440s, Piero's first encounter with the court of Federico da Montefeltro (1422–1482), one of the most important figures in Renaissance history, was recorded. A great soldier, strategist, discerning diplomat, man of letters, and lover of art, Federico, who rose to power in 1444 and became duke in 1474, grew rich through conquests that enabled him to gradually expand the confines of his duchy. The fruits of these military undertakings allowed him to guarantee Urbino its status as a capital of humanism and of the early Renaissance in an ambitious project that was

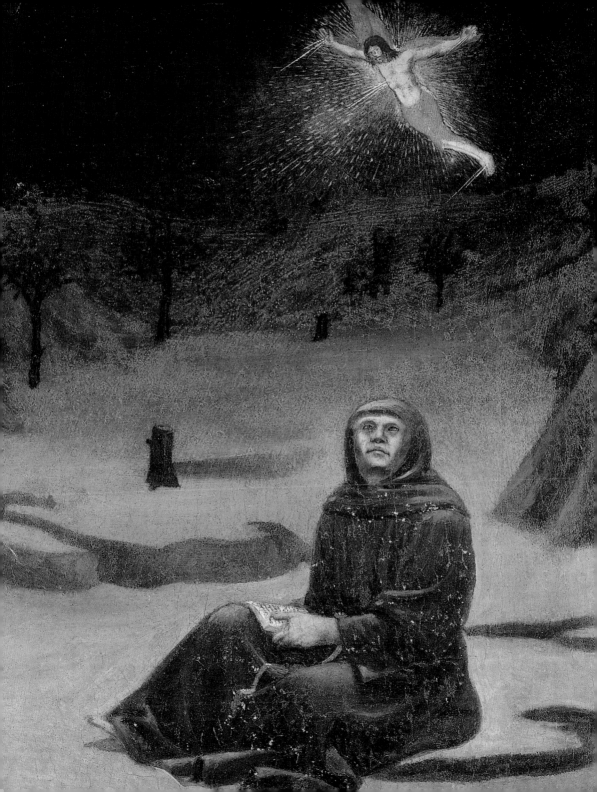

a definite success. Among the figures involved in the undertaking was Piero della Francesca, who, Vasari tells us, was "employed by Guidobaldo Feltro, an old Duke of Urbino, for whom he made many beautiful pictures of small figures, most of which have come to grief during the numerous wars from which that State has suffered." Thus, Piero's first encounter with the culture of Urbino is with Federico's father, and caused the young man, who was scarcely over twenty, to elaborate a series of works along a line that include two paintings of *Saint Jerome* from around the 1450s. But Vasari was talking about more than one court, and not just in Urbino. He writes: "Having won a good name for himself at the court of Urbino, Piero wanted to make himself known elsewhere and so he went to Pesaro and Ancona. He was at his busiest there when Duke Borso summoned him to Ferrara where he decorated many of the palace rooms. These, however, were afterwards destroyed by Duke Ercole the elder when he renovated the palace; and so there is nothing by Piero left in Ferrara

save the frescoes he did in a chapel in Sant' Agostino, and even they have suffered badly from damp." Ferrara, together with Urbino, where Piero would return in the 1470s, was then the flourishing court of Leonello d'Este (1407–1450) who soon died, leaving his power to his brother Borso who, as Vasari recounts, called upon Piero to take advantage of his services. In the age of the principalities of Leonello and Borso, Ferrara was the center of avant-garde artistic experimentation where the voices of Tuscan painting—probably brought there by Agnolo di Siena—and the references to the illustrious messages of Leon Battista Alberti, Donatello, and Mantegna all flowed together. The documented presence of paintings by Rogier van der Weyden further attests to the contact with Flemish culture that certainly influenced Piero della Francesca's painting, particularly in his rendering of the landscape and his chromatic values. The masterpiece called *Borso d'Este's Bible* stands out as a symbol of the cultural importance of Ferrara. This volume that holds

both the Old and New Testament was made for the duke by different artists between 1455 and 1461, and constitutes a masterpiece of Italian Renaissance illumination. With this codex, book illustration acquired the new language of the Renaissance, turning late Gothic fantasy and elegance into a new rationality, becoming the synthesis of the previous artistic experiments.

But what could Piero have seen in Ferrara? To start with, a collection of gems and ancient coins collected by Duke Leonello. As has been said, one of the most important aspects of humanism was the recuperation of antiquity, of the classic world, of Greek and Roman culture and art. The cult born out of this started a race to guarantee the survival of pieces from antiquity that were the most elegant and rare. The shape of man, perhaps the idea of man itself, could have been read on those testimonials, in some way told by the rediscovered classic texts, and made into images in the sculptures and, wherein it might interest us, in the coins and the gems. This style spoke of a humanity that was proud, elegant, and splendidly and simply beautiful in its harmonious relationships, and in its bodies drawn within the balance of proportions, in the elegance of very particular gestures, hairdressing, clothes, and expressions that flourished in paintings of the quattrocento.

All this happens on a thematic, iconographic level. But there is another encounter that Piero made in these years that influenced his painting on a technical level as well as a compositional level. This is his encounter with Flemish culture. During this period, in fact, Rogier van der Weyden's (c. 1400–1464) presence in Ferrara is required by the painting of a Deposition. Flemish painting is above all known for having introduced oil painting to Italy, allowing the painter to obtain more refined control over light. The other noteworthy aspect is a new attention to interiors in which merchants and noblemen are portrayed in settings saturated with precious objects and details full of

symbolic merit. To this may be joined an attention for exteriors, with views that very carefully bring together every descriptive detail fused into the knowledgeable use of light to create atmosphere. These two aspects—light and attention to detail—certainly influenced Piero's painting, which gradually opened up to a lingering 'Dutch-style' in detail and landscapes. But Piero gathers another fundamental aspect of Rogier van der Weyden, which is his sense of a plastic construction, a sense of monumentality, that is already a hybrid of Flemish color and the monumentality of Tuscan drawing. Once again, two cultures come together to generate a new form that insists upon an equilibrium between synthesis and detail, between the monumental and the graceful. Piero finds himself observing this precise phenomenon, and even has the opportunity to see the work of two great wood inlay artists: Leonardo and Cristoforo Canozzi of Lendinara, who were involved, since 1449, in the decoration of the study dedicated to the Muses that the duke

had made at Palazzo Belfiore. This type of decoration that the artist played with to create illusionistic effects through the use of perspective is clearly an additional element that is useful in our attempt to reconstruct the development of Piero's style.

Piero left Ferrara early in 1451 for Rimini, leaving behind a nucleus of frescoes in Este family castles and in the church of Sant'Agostino, all of which are now lost. Meanwhile, the protagonists of the Renaissance continued to cross one another's paths in reciprocal influences: in Rimini, Piero met Leon Battista Alberti, the artist who dictated the compositional parameters for an entire epoch.

Leon Battista Alberti (1404-1472) was only a decade older than Piero, but his training was completely different. He represents the cultured and refined humanist of the times perfectly. Born in Genoa, he worked in Venice, Padua, and Bologna, studying Greek, Latin, and law. He read the classics, wrote comedies, and admired ancient

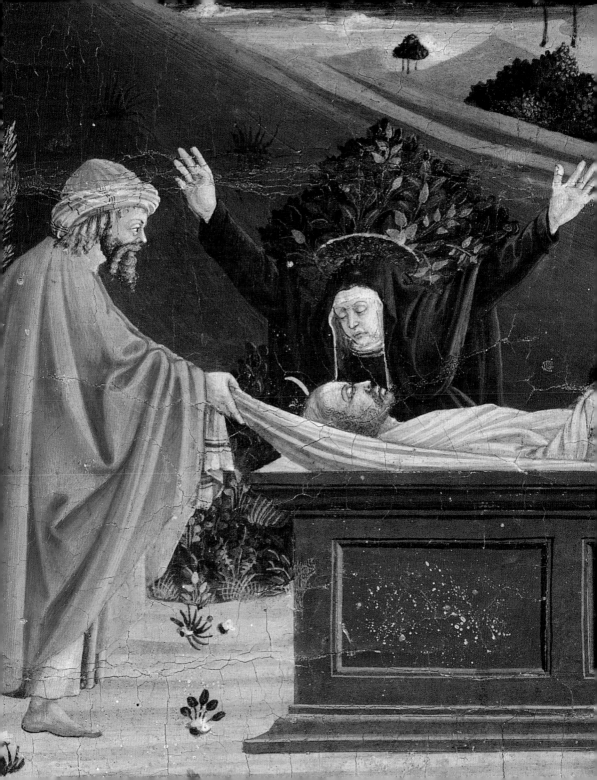

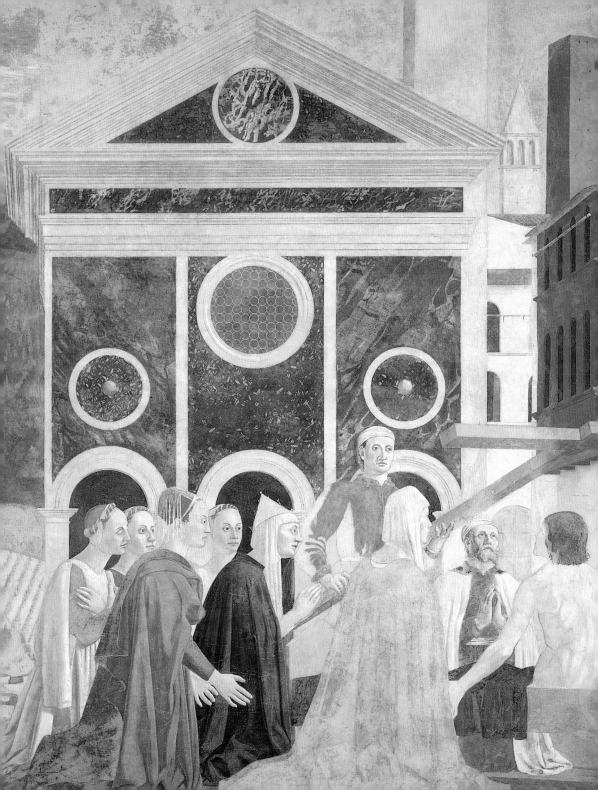

The Legend of the True Cross
Finding the Three Crosses and the
Proof of the True Cross (detail),
1452–1459
Arezzo, San Francesco

art. He is a man who appears to be the epitome of humanism. All his refined culture informs the pages of one of the fundamental texts for theoretic thinking at the time: his *De pictura*, of 1435. In the second half of the quattrocento he concluded the writing of another fundamental text, *De re aedificatoria.*

As an architect, he expressed his own esthetic considerations in the church of San Sebastiano in Mantua, in the façade of Santa Maria Novella in Florence, in the restoration of the church of San Francesco in Rimini, and in his transformation in the Malatesta temple. Piero della Francesca was also in Rimini mid-century, where he participated in the creation of *Saint Sigismondo and Sigismondo Pandolfo Malatesta* in the same temple.

The two artists almost certainly met; in what manner did the theories of one enter those of the other? First of all, Alberti believed in the role of the painter as the world's inventor. This world need neither imitate antiquity nor even real life. Rather it should be the result of understanding a series of rules regarding vision that are the same physical laws by which man may read and experience the world. The goal of painting is to reconstruct and reconstitute these laws. From here, a series of mathematical considerations is necessary to correctly reproduce objects within space. While we have already spoken of the mathematical skills of Piero, it is interesting to dwell upon the means through which painting must offer its narrative, be it man or object. These means must look at sculpture, which alone must obey the rules spoken of for intrinsic, physical reasons. Thus, in order to transfer such automatism, such three-dimensionality even into painting, Alberti invited painters to do modeling exercises: "Piero was, by the way, very fond of making clay models, which he would drape with wet cloths arranged in innumerable folds, and then use for drawing and similar purposes," wrote Vasari. This is one of the first fundamental points of contact used to reinforce—using theory—Piero's natural tendency towards drawing the volume, the

mass, and the weight of bodies. Alberti also points out the values of composition. The narration must be able to guarantee the readability of the work, thereby calling for a series of requirements.

The first requirement is the need for voids. Alberti blames painters who, for the sake of displaying imaginative images, leave no spaces empty, trespassing every limitation. The image, according to Alberti, needs solitude; it needs empty spaces as if they were pauses that offer communicative strength and expression to the object depicted. If we consider the Arezzo cycle, the Malatesta fresco, or all Piero's work in general, this law of voids, seems to be fully understood and expressed in the work of the Master of Borgo Sansepolcro. Sigismondo's profile is drawn within a void, like many figures from the Arezzo cycle. Madonnas are isolated in space as in the *Madonna del Parto*, or the secular dialogues in the *Flagellation*. With eyes set on the latter, it is easy to read another of the rules laid out for painters by Leon Battista Alberti:

the *theory of slowness*. Alberti wants the void because in the empty space it is necessary to build equilibrium and moderation. There is no need to imitate convulsive gestures from life; rather an archaic *dignitas* must control the poses and movements. Even now everything in Piero's painting appears to be suspended, immobile, in pose. In the *Flagellation,* figures have been inserted within a mathematical, classic, yet contemporary space that is the perfect interpretation of architecture. They are immobile, and yet they are mentally involved in the flagellation of Christ.

It is rare to find drama in Piero's work, and even when it occurs there is some other element that balances it out to temper its redundancy. It is all about spatial and human balance. Slowness, silence, sobriety, and composure in other words, monumentality in a time that is not duration, but eternity. The last law that we may extrapolate from Alberti's writings is the one governing the use of light. Each color must have values of white and black, the chiaroscuro that makes

it possible to create volume, and thus, once again, monumentality.

Piero "succeeded in maintaining the dawnlike tonality derived from the art of Veneziano and the solar and pacific harmonies that were later enriched by the festive colors from the North," wrote Focillon.

Thus, from one of the most important Renaissance figures whom he met in Rimini for the work entrusted to him by Sigismondo, Piero learned a theory that nonetheless fit into a natural Giottesque tension: a love for volumes that he had already matured in his Florentine period and was perhaps innate to the painter's spirit. Perhaps this is nothing new, but it is certainly a compositional rationalization that would govern his works from that time on and prepare him for his undertaking at Arezzo.

Piero was in Arezzo after 1452, the year Bicci di Lorenzo, a painter to whom the cycle *The Legend of the True Cross* was originally entrusted, died. For the events that concern the work, the reader should refer to the entries regarding the individual works. Here we will only discuss the influence Alberti's lesson had on the essentiality of spaces, the calibration of the full spaces and the voids, and the generation of a humanity that leans toward the icon in its terrestrial, human, perfection.

The Arezzo cycle is unanimously considered Piero's masterpiece. The painter rapidly received confirmation of its magnificence in a long series of commissions from the city. Nonetheless, the complexity of the work necessitated a very long period of time. Meanwhile, towards the end of the 1460s Piero was in Rome making some frescoes at the Vatican for Pio II; unfortunately, none have survived. In Rome he had another fundamental encounter in the history of art, with Antonello da Messina.

But of this Roman period—in which he was certainly able to deepen his knowledge of places from of the classics and verify the compositional harmonies and rhythms of the

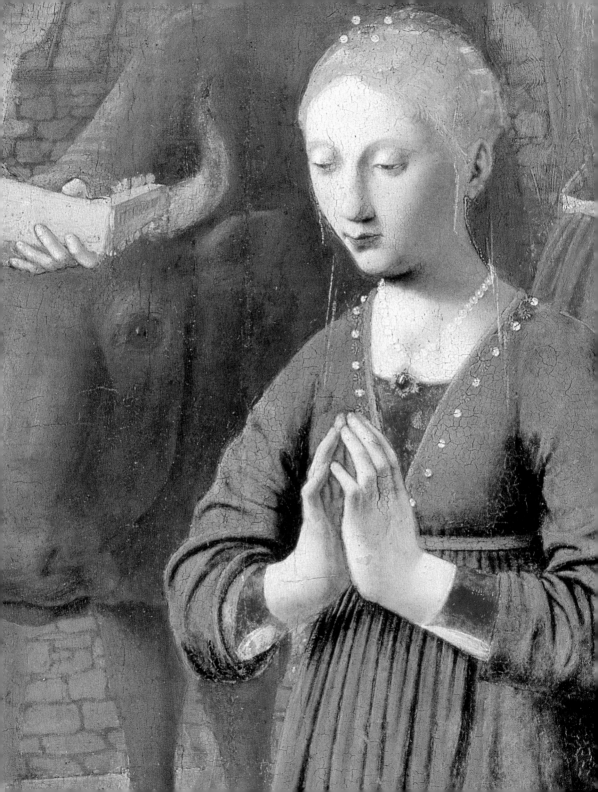

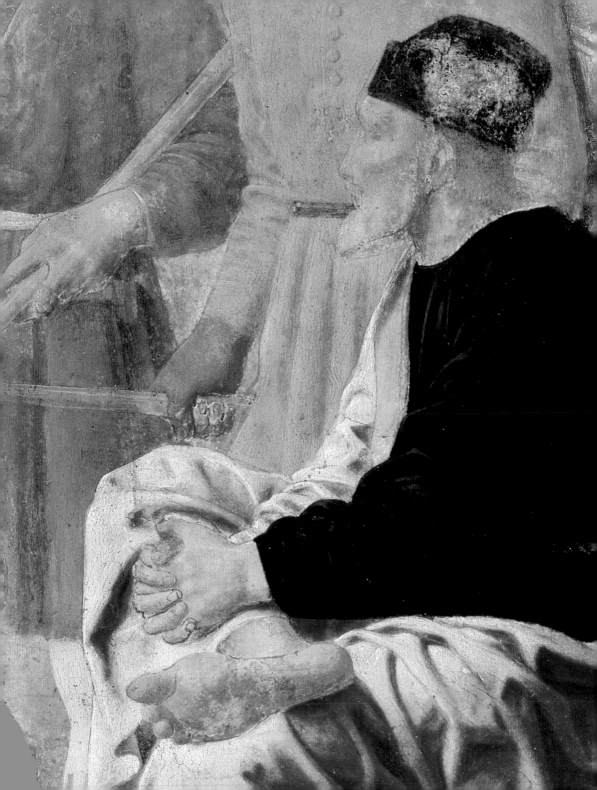

ruins through his own direct experience—the only figure left today of the four Evangelists for the painting in Saint Michael's chapel at Santa Maria Maggiore is a single Saint Luke.

Vasari's hypothesis is that Piero left the city in 1459 upon the death of his mother, to which some scholars tie the *Madonna del parto*, the umpteenth masterpiece of balance, formal essentialism, measure, and extreme emotional depth; an icon that is sensual and Western in spirit.

From a Rome that was ready to glow in the glories of its Renaissance, Piero returned to Tuscany where his last great works awaited him. This final group clearly shows the series of influences whose essential lines we have attempted to trace. Monumental thought remains, but it blends into the influence of the Northern masters. Piero returns to Urbino in the 1470s to write one of the Renaissance manifestoes on painting. At an increasingly Dutch court, Piero continued the alchemy of the balance between his sense of form and the suggestion of innovation.

His portraits of the Duke and Duchess of Montefeltro constitute one of his best-known works of the period, and they are a synthesis of the trends that flowed together into a single, ingenious operative mode. The landscapes are Dutch, but the line that draws the profiles is classical, Florentine, and in essence is that of Pisanello. The so-called *Brera Altarpiece*, in which a concert of reminiscences becomes a masterpiece, was completed in Urbino. After the *Madonna of Senigallia* from the late 1470s, the time had come for Piero to weigh his achievements. In 1486 he was working in Rimini, in his will he was "still sound in mind, spirit, and body," and now full of experiences that have come down to us in his writings: the treaty *De prospectiva pingendi* and the book *De quinque corporibus regolaribus*.

His earthly affairs are closed; condemned by age to miserable blindness, Piero della Francesca died on October 12, 1492, the same year the New World was discovered on the other side of the ocean.

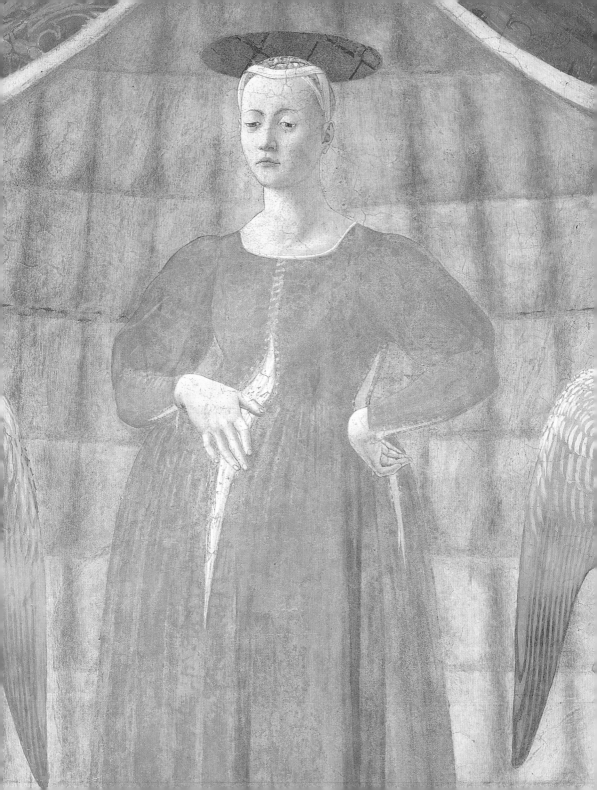

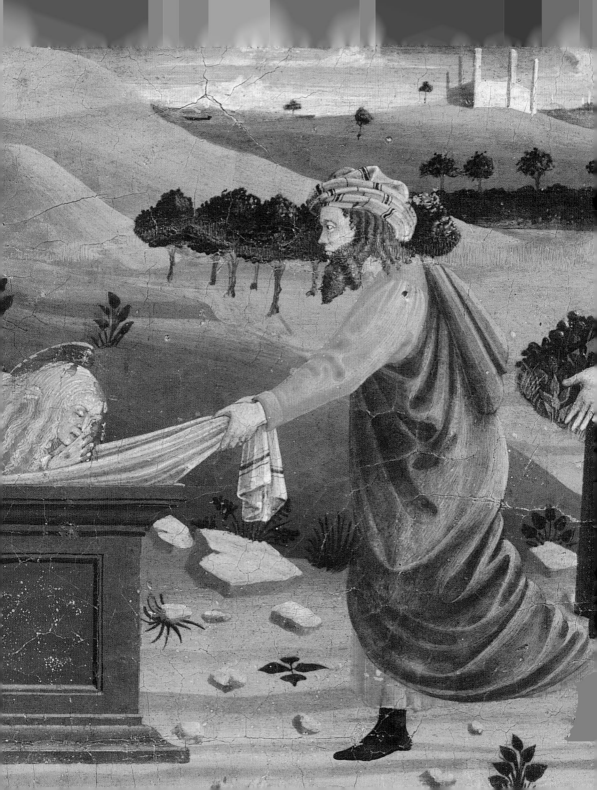

After attempting to place the historic moment lived by Piero within the general history of art, and after positioning his life's events within that precise moment that was humanism, we need to offer a final evaluation.

His life experiences, his travels, and his artistic encounters result in one of the most original pictorial forms of his epoch. Playing between an abstract tendency and a clearly opposing love for naturalism, his painting has some very precise characteristics.

First and foremost are his measures. For Piero, man is the most complex object to which he must apply the laws of mathematics. The slender, slight typology of the small and elegant Botticelli head contrasts with the monumentality of Giotto and Masaccio, but measure remains all-important. Heads are vast and solid, while facial features are delicate. The figures are immobile, or rather endowed with a movement that withstands the centuries. Alberti's lesson imposed balance, the same as that measured on the powerful ankles and feet created to sustain the bodies' weight. The impersonality of his subjects is born out of the identification of a precise type of human, with a psychology that is foreign to melodrama and to current events, and repeated endlessly. The slowness, the supernatural and the impassivity are perhaps simply an attempt to make the figures he created eternal.

Then there is the world, architecture, and landscape. His architectures come down from the postulates of the classic world. Essentially weight and luminosity govern works in which perspective becomes the supposition of man and his presence, and not merely an exercise in skill. These architectures that are inhabited by the humanist man are arranged in nature. The latter is no longer a bird's-eye-view offering a planimetric rendering in which detail became the symbol of that which could not be represented: nature becomes structure. The Flemish render it as atmosphere; Piero renders it as atmosphere structured according to precise rules. It is a nature that dares to be architecture in its attempt to have structural

or formatted values, like the tree-column discussed in the entries for the paintings. It is a landscape that is no longer accessory, but an integral part of the celebration of mankind. Then there is light. Having understood the secrets of Domenico Veneziano, Piero builds the images with color, and builds the color with light. He meditated on painting, as has been said, at noon, when the zenith's light once again confers a homogenous balance upon everything, canceling shadow from the earth. It is the most intellectual, the most abstract hour.

These are the characteristic principles that may be traced in the masterpieces of Piero della Francesca. In order to understand the genesis of his work, it is necessary to place it alongside a metallic ingeniousness that would grow in very distant generations, as was the case for the metaphysical and representational works of the novecento group in the twentieth century. Giorgio de Chirico, Felice Casorati, and Mario Sironi all interpret Piero della Francesca's lesson, providing a new reading in another key.

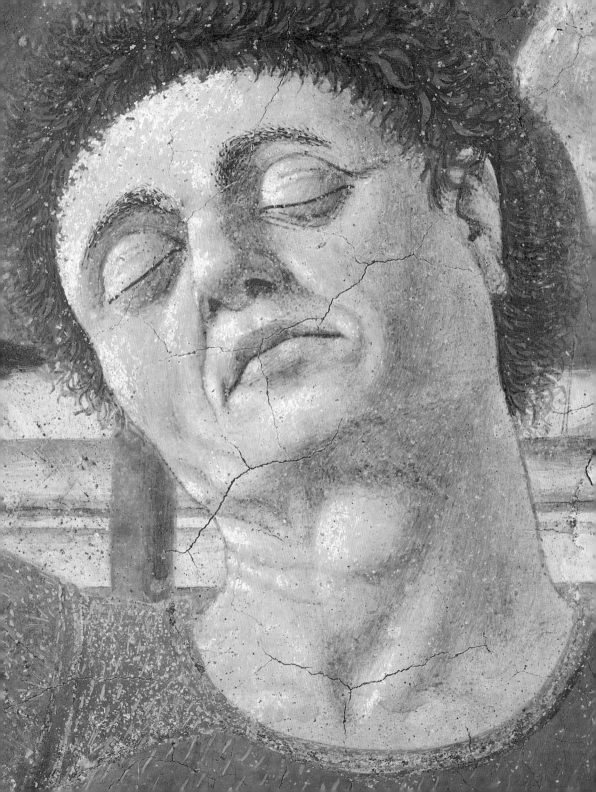

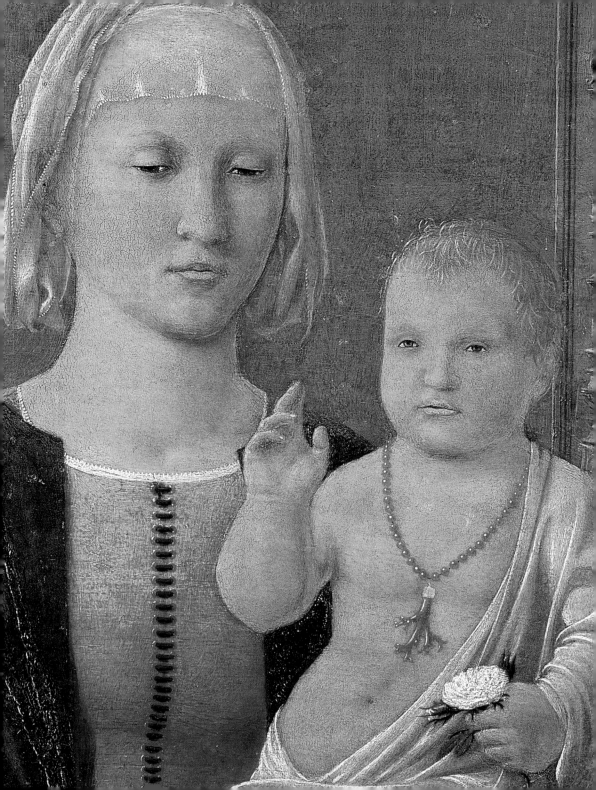

The Masterpieces

Polyptych of the Misericordia

1445–1462
Oil and tempera on panel,
approx. 273 × 330 cm
Sansepolcro, Pinacoteca
Comunale

The layout of the work betrays Piero's early training: in compositional terms, in fact, it is decidedly linked to the medieval tradition. Each figure is isolated against a golden background that, moreover, was the request of the work's patron, who by contract stipulated the work to be completed in three years, and included an engagement to restore it if necessary in the following decade. The confraternity of the misericordia of Sansepolcro commissioned the work from Piero on June 11, 1445, for the sum of 150 florins. This happened just one year from the completion of the masterpiece by a Sienese artist, Stefano di Giovanni, known as il Sassetta, employed at the church of San Francesco in Borgo Sansepolcro for the *Apotheosis of Saint Francis.*

The predella with the *Deposition* at the center and the two lateral pilasters with saints are not attributed to the master's hand by critics. The iconography follows a scheme that is well defined in tradition. The Madonna protects a group of devotees among whom a self–portrait of the artist may be recognized immediately to the right of the Virgin. The treatment of the latter differs with respect to previous ones, as a leather belt tied with a double cord is added in reference to her virginity.

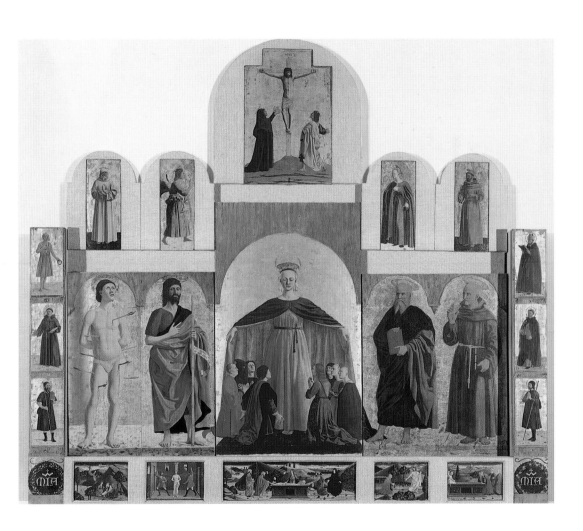

85

Polyptych of the Misericordia
Madonna of Mercy

1445–1462
Oil and tempera on panel,
134 × 91 cm
Sansepolcro, Pinacoteca
Comunale

The Madonna is a solid geometric volume, refined by a face that synthesizes the master's future style. Her lips are similar to those of the Madonna by Domenico Veneziano, the cut of her eyes recalls the *Madonna and Child* of Melun by Jean Fouquet. The halo has the same diameter as the crown and is portrayed in perspective. Above the Madonna is a *Crucifixion* that reaches a rare dramatic tension in Piero's successive works, and this drama comes from the Madonna's gesture and the noble pose of Saint John. Its source is Masaccio, more specifically his *Naples Crucifixion* for the use of volumes that become drama in action. The figures that would appear in the master's subsequent works also appear here: Saint Sebastian and Saint John in the panels to the right of the Virgin, Saint Andrew and Saint Bernardino to the left. Masolino's peaceful nudes and Masaccio's worried masses in the Brancacci chapel are the guide to a geometric synthesis that had not yet become theory and concerns a single leader of a school of painting: Giotto. The concessions to the ancient style in the use of gold and the dimensions of the Virgin, who is twice the size of the devotees, don't appear to support the modernity of the geometry of the faces, the bodies, the drapery. Yet that which is archaic is transformed intelligibly by the space. The gold becomes light and back-lighting that exalts the volumes, and the play of dimensions becomes monumentality. Color is spread in compact fields that are Giottesque. The vestments are sober, with rare concessions to detail in the diadem of the Virgin, in the stones of her crown, and the arm of one of the women worshipping.

The sculptures made of color and the volumes that synthesize shape, such as the foot of the Virgin, express a placid and hieratic stasis that is not distant from man, as in Byzantine art. Rather, it is pure invention by an elegant humanism, and describes man by likening him to God in the search for the perfection of form.

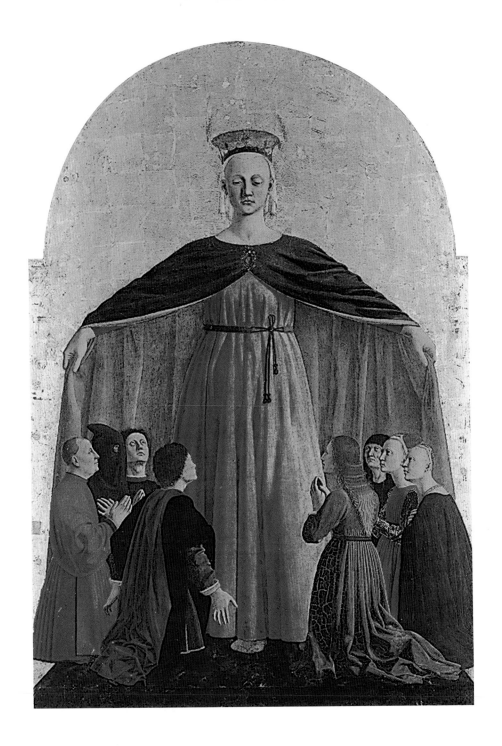

Saint Jerome Penitent

1450
Oil on panel, 51 × 38 cm
Berlin, Staatliche Museen
zu Berlin, Preußischer
Kulturbesitz, Gemäldegalerie

This work is by a painter who is still searching for a style. It represents one of the most frequent themes in sacred iconography, or, to be more precise, Saint Jerome with his distinguishing elements: the Lion, barely recognizable in the lower left, and the cardinal's hat, at the lower right. The saint is shown concentrated in prayer, in a mass that is not volume, but appears to come closer to the Sienese taste for form. We are in the painter's youthful phase, which some critics liken to the figure of the Sienese artist Sassetta. The painting, after many events that have compromised its condition, was restored to perfect condition in 1968. The cleaning revealed a minute scroll to the lower right, bearing the painter's name and date. Because of its compositional layout and a certain attention to detail—which may be observed in the gilding on the covers and the bookmarks between the pages of the volumes amid the stone—, the painting appears far away from the austere essentiality of the artist's mature phase, and belongs to that series of works that, according to Vasari, Piero painted at the beginning of his activity between 1449 and 1451. The work remains an exercise of those formulas, here still in their embryonic state, that would develop into the final style of Piero della Francesca. In addition to the treatment of the figure, here limited by its geometric strength, the landscape offers a taste of those luminous overtures, *en plein air*, which we will see again in the double portrait of the Montefeltros, in the *Victory of Constantine over Massentius*, or even in the *Nativity* in London. The descriptive value of the landscape that is manifest in the trees reflected in the stream and in the plant life, which nonetheless have an antique flavor, will gradually shift towards results that critics attribute to Flemish influences. Also noteworthy is the typological elaboration of the tree, which will emerge with increasingly architectural and compositional values in his subsequent works in the tree-column in the *Baptism of Christ* and those in the Arezzo cycle, increasing its plastic, geometric values.

The Baptism of Christ

<u>_c._ 1450</u>
Tempera on panel,
167 × 116 cm
London, National Gallery

The scene is immersed in the light of the sun's zenith, at the most abstract and most intellectual time of day, midday, when bodies lose their shadow, nearly their contact with the earth, and their physicality. Considering the precedents of the tradition—Fra Angelico or Masolino—Piero's painting emerges as overwhelmingly modern, monumental, solid, and yet suspended in an enchantment of gestures and balances. Christ, the white dove, and the hand of the Baptist constitute a central axis between the tree and Saint John. To the left the three figures balance the group of men and the bather to the right. The baptism is the sacrament of rebirth and purification. It is celebrated in the painting by springlike nature, in a clear sky, and in the limpidity of the riverlet: purity is celebrated in a serene landscape in which Borgo Sansepolcro itself may be seen in the background. Christ and the Baptist are standing on dry ground in a variation on iconographic tradition in which the first stands immersed up to his knees in water and the second is kneeling. The Baptist's gesture is elegant and respectful all at once. There are different interpretations for the three figures to the right of Christ. Historians tend to identify the central figure with Concord and the angel wearing an olive wreath with Peace. Others suggest the allegory of the three theological virtues or the theme of the Three Graces. In addition to elements that do not permit a certain identification, there is the plasticity of Christ, a classic volume of marble, with eyes cast down in awareness of his destiny, and a mass of light builds and pushes the extreme consequences of the master Domenico Veneziano's luminarism. Behind the foreground of gazes that never cross are figures wearing Near Eastern dress, one of whom gestures skyward towards a mystery hidden from the viewer by the tree, to confer a supernatural quality upon a very human, very natural Tuscan landscape.

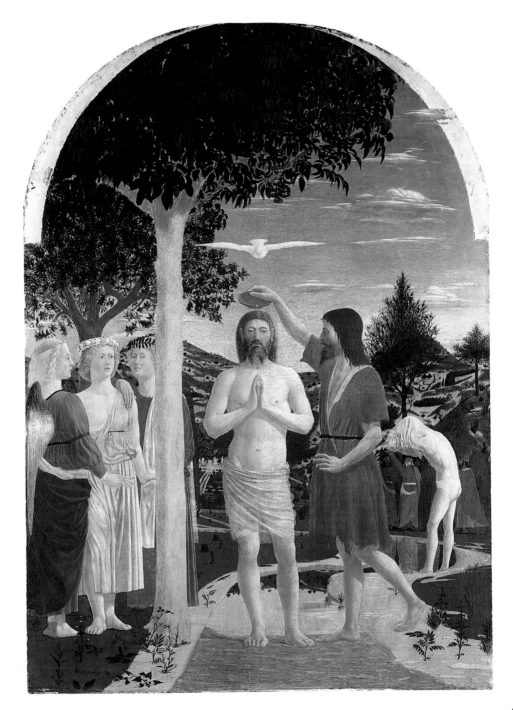

Portrait of Sigismondo Pandolfo Malatesta

1450–1451
Oil and tempera on panel,
44.5 × 34.5 cm
Paris, Musée du Louvre

This painting joined the Contini Bonacossi Collection in Florence around 1930 after it was transferred in 1889 from St. Petersburg to the D'Ancona Collection in Milan.

Having recently joined the Louvre, the work underwent an in-depth analysis that excluded the hypotheses that it was a nineteenth-century fake; subsequent restoration made it possible to eliminate the heavy nineteenth-century repainting that had significantly altered the painting's reading; some of the original colors had been rediscovered, particularly in the hair area. It is not very clear when the painting was made. The first to attribute the work with any certainty to Piero was Longhi, in 1942, when he held that the portrait was used by the master as a model for the Rimini painting. Experts generally agree to position the painting's creation within the sphere of his sojourn in Rimini and thus in the mid-1450s.

Stylistically the painting falls within the portrait painting of the period. It is viewed as if Pisanello's Este profiles had influenced Piero's art. The profile becomes the expression of the individual's singularity. The black background exalts the flesh-color that is bathed in golden light. A thoroughly Flemish taste for detail exalts the gold threads in the weave of his dress. His decisive and ethereal gaze go with the lines of the face. The geometry of the robust neck is continued in the development of the bust.

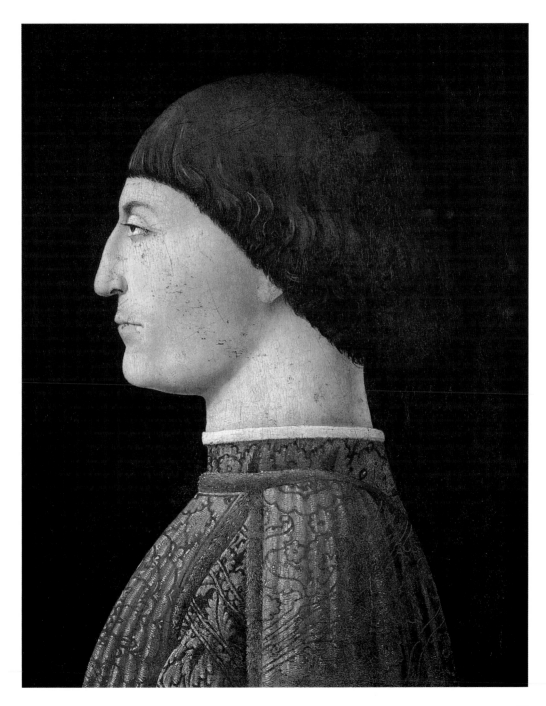

Saint Sigismondo and Sigismondo Pandolfo Malatesta

1450–1451
Fresco transferred on canvas,
257 × 345 cm
Rimini, Tempio Malatestiano

Kneeling in the foreground is Sigismondo Pandolfo Malatesta, Lord of Rimini from 1432 to 1468, facing his patron saint. Although he is viewed in profile as required by the canon for representing the devout patron, Sigismondo is placed in the center of the scene, with larger dimensions and on a plane that is closer to the viewer than that of the saint. His face is on a white ground, in an empty space, that exalts its hard features while isolating them. Piero, mindful of Alberti's lesson, constructs the space while calibrating the elements and freeing himself of every residual *horror vacui*, in a celebration of man that is the *de facto* painterly translation of Albertian humanism . The saint's posture is very informal, and the position of his right leg is surely a means of obtaining an effect of space within the depth of the platform.

At the center of the composition is the Malatesta coat of arms; the motif of its ornaments derives from Roman wall painting. The value of the work is more a celebration of the Rimini Lords' conquest and dynastic right rather than devotional. Criticism highlights the fact that this depiction of Saint Sigismondo bears the features of Sigismondo of Luxembourg, who was crowned by Pope Eugene IV on May 31, 1433, and then went to Rimini, where he knighted the fifteen-year-old Sigismondo. The date appears on the lower right of the frame. Regarding patronage, during Sigismondo's father's time San Sepolcro was part of Rimini's rule and thus Piero could have been called upon either by Jacopo di Alberico di Anastagi, a member of one of the most visible families in the Borgo who became Sigismondo's counselor, or else by Lionello d'Este, at whose court Piero sojourned from 1449 to 1450. The work is still located where it was created, the chapel of reliquaries in the Malatesta Temple in Rimini. Poorly restored in 1820, it was liberated in 1950 from its old repaintings and transferred to canvas.

Saint Jerome and a Donor

c. 1450
Tempera on panel, 49 × 42 cm
Venice, Gallerie
dell'Accademia
On the tree trunk on the left:
'PETRI DE BV[R]GO S[AN]C[T]I
SEP/VLCRI OPVS'; to the lower
right, on the ground before the
kneeling donor, 'HIER. AMADI.
AVG. F.'

The saint depicted in this painting is commonly identified as repentant Saint Jerome, although he does not have his traditional attributes, the cardinal's hat and lion. The kneeling donor reminds us of the second donor to the left of the Madonna in the *Polyptych of the Misericordia* and has the features of Giovanni Bacci, patron of the frescoes of San Francesco, depicted in the *Flagellation*.

On the tree trunk may be read 'PETRI DE BV[R]GO S[AN]C[T]I SEP/VLCRI OPVS', and to the lower right, on the ground before the kneeling donor, 'HIER. AMADI. AVG. F.'. Because Amadi is the name of a Venetian family that lived between the quattrocento and cinquecento, it is suggested that this was a commission from Venice itself. Most scholars, however, exclude such a possibility and assign the inscription to a later date, when the family acquired it. Stylistically the dating was moved to the mid-quattrocento, into the sphere of those works produced for the Italian courts mentioned by Vasari.

There are many references to Flemish art, ranging from the precise description of details to the complex play of light that Piero succeeds in creating by adding a light source illuminating the crucifix behind the saint from below to the sunlight shining on the landscape.

The dramatic intensity of the saint's gaze, the taste for details in the objects—such as the bookmarks in the volumes resting on the bench—and in the landscape that is treated with a rational, mimetic will based on luminarist values that are the legacy of Domenico Veneziano's work. The volumes are handled with the usual plastic-geometric sense. With respect to the Berlin panel of the same subject, here Saint Jerome is characterized by a sculptural vigor that will be Piero's stylistic signature. Powerful, worked in the marble like structure of the painting, the saint imposes his gaze upon a donor, whose head, like a mass of color, is outlined and emerges from the black of the background.

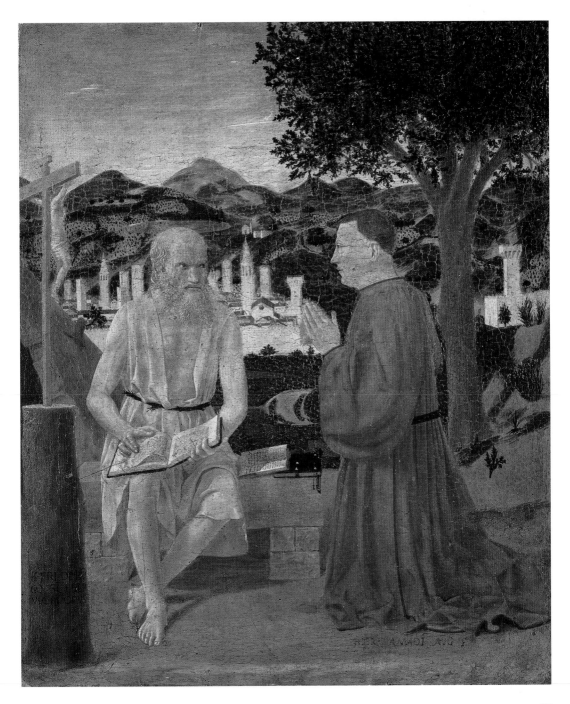

The Resurrection of Christ

c. 1450
Fresco, 225 × 200 cm,
Sansepolcro, Pinacoteca
Comunale

The original location of this Resurrection is presumed to be different from today's, which is the Sala Cerimoniale at the Palazzo dei Conservatori, in the Museo Civico. In 1441 Sansepolcro, a subject of Florentine rule, was deprived of the use of the Palazzo della Residenza, the official seat of the high magistrates. In 1456 Florence returned the use of the palazzo to the conservators and two counsels, thereby returning a certain autonomy to the city. It is at this time that restoration work begins, during which the painting, a symbol of the city's pride and identity, was probably made.

This figure of Christ is imposing in all his determination. To the left, a barren, desolate winter landscape is depicted; to the right, instead, beyond the Resurrection, the landscape is spring-like, pleasant, and serene. Soldiers lie sleeping at Christ's feet and with him they form a pyramid of which they are the base. Beneath the standard the foreshortened soldier is believed to be a self-portrait of Piero. The iconography of Christ depicted frontally with a foot resting on the sepulchre is widespread in Gothic and Renaissance art.

Christ is depicted as powerful as a warrior. The foot resting on the sarcophagus is elegant and the anatomy of his torso is traversed by a groove that continues the verticality from his nose to his stomach. Lacking architecture, the space is defined by the bodies of the guards arranged on two distinct planes. The face of Christ is a portrait of pain; solemn, iconic, and yet realistic. The layout is highly geometric in the construction of volumes and above all in the secret references and schemes that run throughout the fresco. The tree-column on the left of the painting proclaims its classic style, as does the gesture with which Christ gathers his robe that spreads out in drapery, like the gesture of ancient toga-wearing.

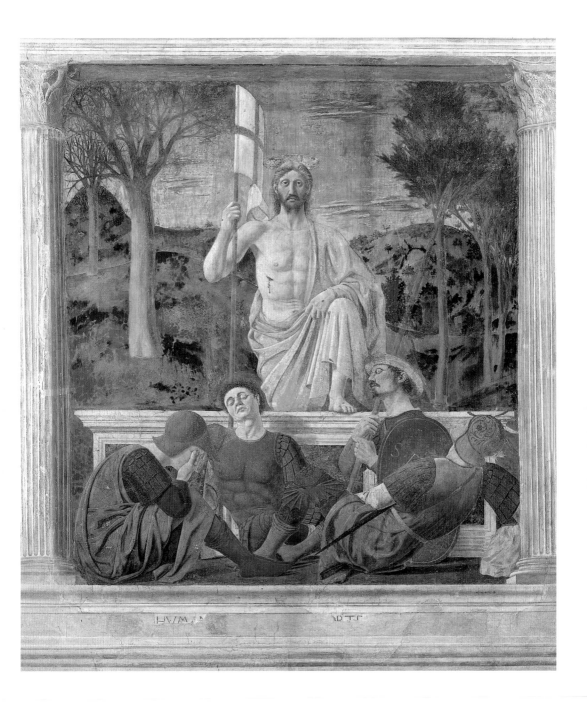

Madonna del parto

1450–1455
Fresco, 260 × 203 cm
including the part of the tent
reconstructed in 1910 and
removed during the restoration
of 1992–1993; dimensions:
approx. 203 × 203 cm
Monterchi (Arezzo),
Exhibition space

This work is one of Piero della Francesca's masterpieces of graphic and chromatic synthesis, a further example of his formal purity. The theme of the pregnant Madonna is unusual in Italian iconography, and much more frequent in Spanish iconography. It was realized at the Church of Santa Maria a Momentana in Monterchi on a wall above a smaller fourteenth-century fresco. The most recent restoration dates from the nineties. This fresco contains literary references to the text of *Ave Maria Benedica Tu es in mulieribus et benedictus fructus ventris tui* (Paolucci) and to Dante's invocation in Canto XXXIII of his *Paradiso*. Other iconographic references have been suggested such as the female attendants in Fra Angelico's *Imposition of the Name* in Florence's Museo di San Marco. The Madonna holds her hand over the opening in her dress that was originally painted a vivid blue that we can only imagine today. In this compact volume one can see the regal composure of the ladies who frequented the spaces in the San Francesco fresco cycle. The pose is typical of Piero's style, as is the form of the baldachin from which the Madonna reveals her beauty to the world. We see this form again in *Constantine's Dream* and in the reliquary held in the hand of Mary Magdalene at the cathedral in Arezzo, but here it is differentiated by the detail in the refined decoration. The two angels are drawn using the same cartoon and are chromatically symmetrical as well, in the parallel of the blue and red, in an almost heraldic sensibility in composition, as is remarked elsewhere. The work was created in seven days. Piero's technique is perfect and he is able to transfer all the ideality of his world upon the wall, the enchantment of the gestures, the solemnity of a woman become icon in the essentiality of color, in the decisiveness of the graphics, and in the softness of the flesh. Crossing the spectator's gaze are not her eyes, which are delicately lowered upon her Son's destiny: rather it is the angels who present us with the miracle in progress.

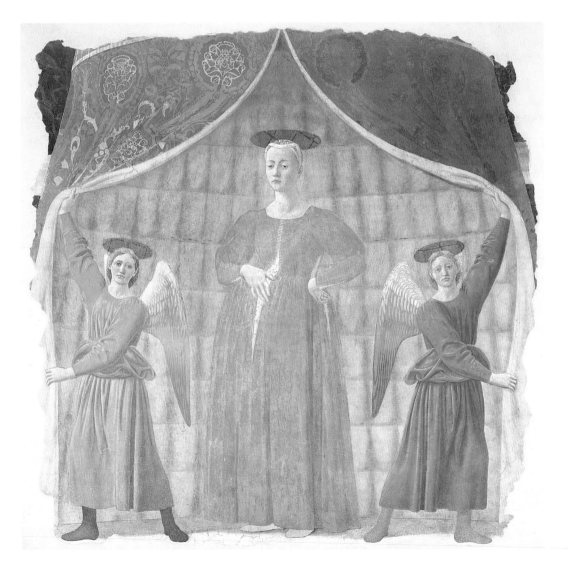

Polyptych of Sant'Antonio

1450–1468
Oil on panel, 338 × 230 cm
Perugia, Galleria Nazionale
dell'Umbria

The Polyptych was painted for the convent of Sant'Antonio delle Monache in Perugia. The present nine-element composition reflects Vasari's description and includes, from the top, the *Annunciation, Saints Anthony of Padua and John the Baptist, Madonna and Child Enthroned, Saints Francis of Assisi and Elisabeth;* in the predella are *Saint Claire, Saint Agatha, Saint Anthony Restoring a Boy to Life, Saint Francis Receiving the Stigmata,* and *Saint Elisabeth saving a Child who has Fallen into a Well.* After it was restored in the nineties, the conclusions of analyses dated the work to between the mid-1450s and 1468. The Madonna is imposingly set at the center of the representation on a throne that recalls the architectonic elements of the *Brera Altarpiece.* Built as a solid mass, it appears to be an homage to Masaccio. Worthy of note is the breakthrough of Gothic architecture with the red pedestal on which the Virgin's throne stands, uniting the two lateral panels with the central figure. The background in all three panels is gold, with silk and gold damask applied to the walls. In the coloring of the faces is a greater realism and attention to mimetic detail than in preceding works. The halo—wide and bright disks drawn in perspective—reflect the heads of the saints and the Virgin. But it is the *Annunciation,* which is stylistically considered to be from a later date, that offers Piero's highly controlled perspective the opportunity to demonstrate an exercise in style. The colonnade, which recalls Fra Angelico's equally dynamic one in the *Distribution of Alms* in Rome, opens with a clear, ethereal vanishing perspective that is mindful of Domenico Veneziano's lesson on brightness, and separates the figure of the angel from that of the Virgin of the Annunciation. The profile of the latter is defined against a black ground, recommended by Alberti, to provide depth. The finger in the book suggests that the Virgin was suddenly interrupted in her reading. In the predella the figures are described with the usual geometric volumes. At the center is the second nocturnal painting after *Constantine's dream.*

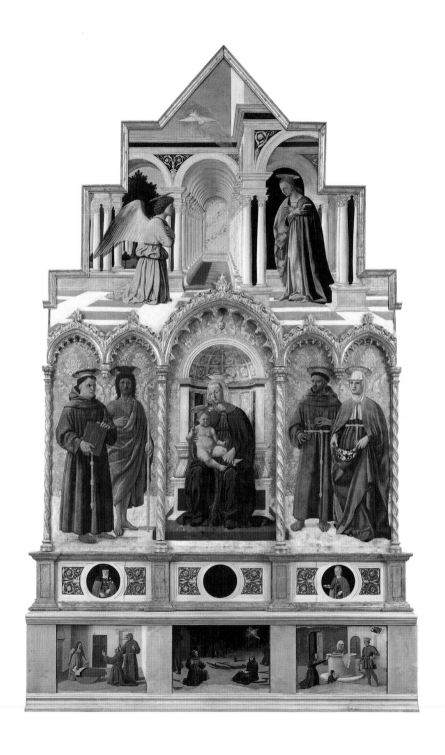

103

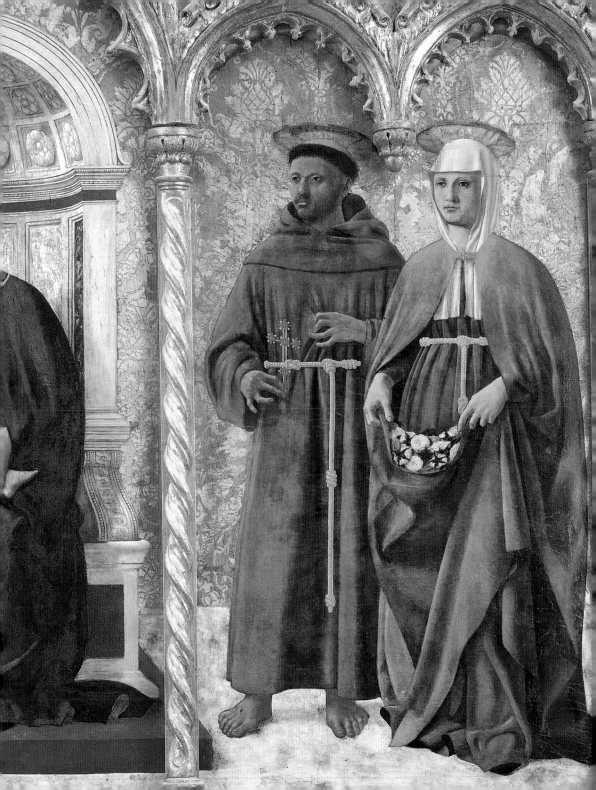

The Legend of the True Cross

1452–1459
Fresco (entire chapel)
Arezzo, San Francesco

The iconography of one of the most beautiful fresco cycles in Western art was born out of the legend, revised in the thirteenth century by Jacopo da Varagine in the *Legenda Aurea*, about the triumph of the Cross that, from the death of Adam, led man to salvation.

Piero follows the traditional scheme dividing the story into three registers: the lunettes at the top and two rectangular sections in the lower registers. The symmetry of the layout is perfect in the lateral walls. In the upper section two episodes set outdoors face one another, in the middle register are two courtly scenes, and at the are bottom two battle scenes.

In the upper register of the rear wall, to each side of the window, are two figures of prophets, in the middle order there are two more 'vulgar' scenes, while the lower has two more solemn scenes. The scenes of the cycle include: *The Death of Adam, The Adoration of the Holy Wood and the Meeting of Salomon with the Queen of Sheba, Burial of the Wood, The Annunciation, Constantine's Dream, The Battle of Constantine and Massenzio, Torment of the Jew, Discovery of the Three Crosses and Proof of the True Cross, The Battle of Heraclius and Chosroes, The Exaltation of the Cross, Angels,* and *Figures of Saints and Prophets.*

Once the cartoons were prepared in sections that, put together, corresponded exactly to the measures of the chapel's frames and lunettes, Piero made the drawings with extreme precision, leaving no room for improvisation during the final execution. The *buon fresco,* or 'true' fresco technique, is complemented by a dry technique typical of painting on board. Piero uses pigments that are bound by oily substances in order to obtain particularly luminous effects and high definition for certain figures. Among the assistants who participated in the frescoes were Lorentino d'Arezzo and Giovanni di Piamonte.

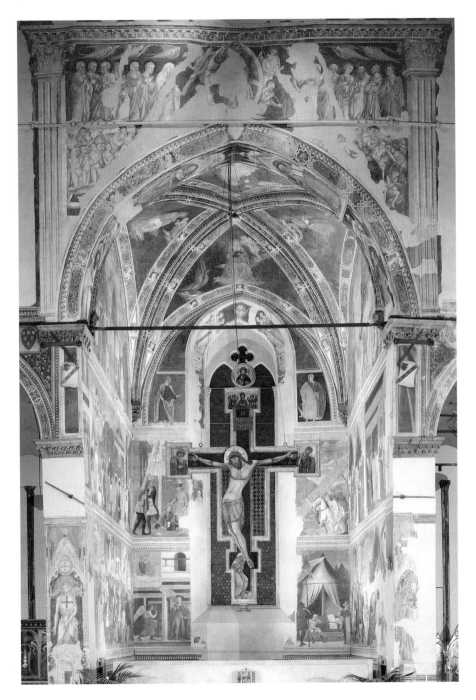

The Legend of the True Cross
The Death of Adam

1452–1459
Fresco, 390 × 747 cm
Arezzo, San Francesco

The fresco, in the large upper lunettes on the right wall, depicts three moments relating to the death of Adam and the birth of the Cross's tree. In the first scene, starting from the right, Adam, on the verge of death, begs his son Seth to ask Archangel Michael for the oil of mercy, which could save him from the clutches of death, but instead the archangel gives him seeds from the tree of sin. Upon the death of Adam, Seth plants these seeds in his mouth and from it grows the tree of the True Cross, symbol of humanity's salvation. In the second scene, Adam, gravely ill, is supported by Eve. In the third, Adam's descendants crowd around his corpse; at the center stands the tree of the Cross, born from the mouth of the ancient forefather. The nude man seen from behind leaning on a stick was inspired by antiquity, and could be an allegory of Death. The person standing to the left dressed in blue and red, instead, should be either Christ, the new Adam, or King David, head of the lineage from which the Savior descends. From their dress, the man and woman standing aside on the left would suggest Hercules, who in the Middle Ages symbolized the Redeemer, and Alcesti, whom Hercules brought back to earth from the underworld. The extreme naturalism that Piero applies to the details of how time passes for mankind is unique. The figuration is divided by the powerful tree under which the figures, in their solid elegance, are distributed in a composed and yet agitated representation of gestures and emotions.

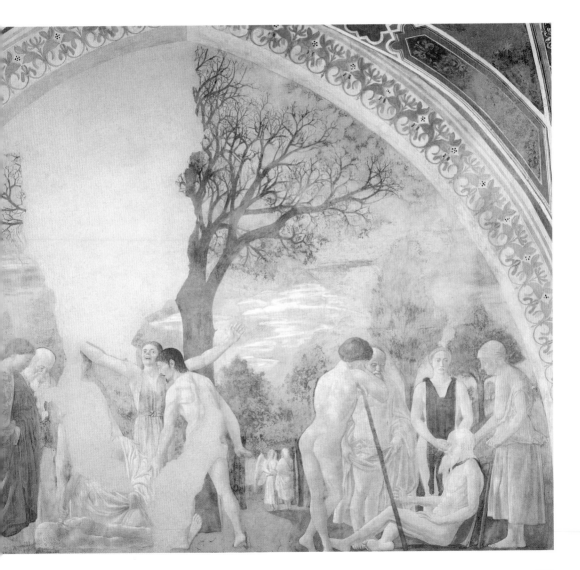

The Legend of the True Cross
The Adoration of the Holy Wood and the
Meeting of Salomon with the Queen of Sheba

1452–1459
Fresco, 336 × 747 cm
Arezzo, San Francesco

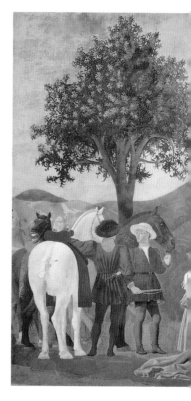

At the center of the fresco, the tree of the Cross has been cut down and used as a little bridge crossing a river; before the bridge, the Queen of Sheba has a premonition that Christ will be crucified on that wood and thus she stops to worship it. To the right, however, during the meeting with Salomon at his palace, the queen reveals her premonition. The king understands that this signifies the end of the reign of Israel and has the wood buried. The scene was interpreted as an allegory of the reconciliation of the Eastern and Western Churches. Salomon may be recognized as Cardinal Bessarione, one of the great supporters of a crusade against the Turks, and his presence qualifies the scene as propaganda. The wood marks the division between the two scenes that depict two moments in courtly life, characterized by the use of saturated colors. The classic layout of the architecture of Salomon's palace highlights Piero's rigorous perspective capability and the importance of Leon Battista Alberti's legacy. The layout is extremely balanced. To the left is the outdoor scene, to the right an interior, and a strong column divides the composition. The figures are built within the geometry of color. To the left the grooms with the horses and the ladies alongside the kneeling

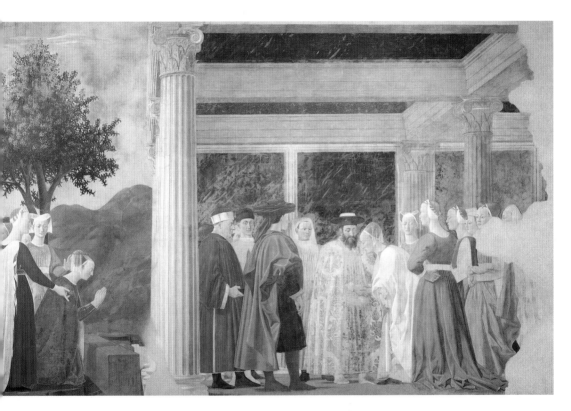

queen fill the ideal cone projected by the two trees. The glimpse of the horses, which recalls Pisanello and Paolo Uccello, gives depth to the plane. Even the ladies, who are extremely elegant in their dress and posture, draw on the noble profiles of Pisanello. Gesture is suspended in poses that sometimes look like the choreography of a dance, and the figures, as if they were sculpted in stone, define the atmosphere typical of Piero della Francesca's style, in which the narrative synthesis isolates the moments and offers them in their formal absoluteness.

The Legend of the True Cross
Burial of the Wood

1452–1459
Fresco, 356 × 190 cm
Arezzo, San Francesco

The scene presents itself on the same register as the court of the Queen of Sheba. Salomon, who has learned from the queen that "upon that wood" from the bridge "was to be hung one whose death would destroy the kingdom of the Judeans," has the wood removed and buried in the "interior depths of the earth". The Holy Wood was thrown into a pond that would become the Healing Pool of Bethesda.

According to Focillon, the meticulousness with which the veins of the wood are described expresses the passionate attention Piero paid to object's substance, defining him as a painter of reality, although he is also a marvelous genius of abstraction.

The Sacred Wood fills the scene diagonally and is supported by figures that are churlish and disheveled but extremely human: fatigue has left them rumpled and is expressed in detail in the falling clothes and the closed lips of the second laborer. The hand evident in this painting is different from Piero's: the fabric is made in a heavy manner, the light is metallic and deprived of those subtle lighting effects that are characteristic of his style. Even the way the men's curled hair is detailed is much coarser and less refined with respect to Piero, and here Longhi identifies the hand of Giovanni di Piamonte. The worker carrying the wood prefigures Christ carrying the cross in a continuous play of references that construct an additional level of interpretation.

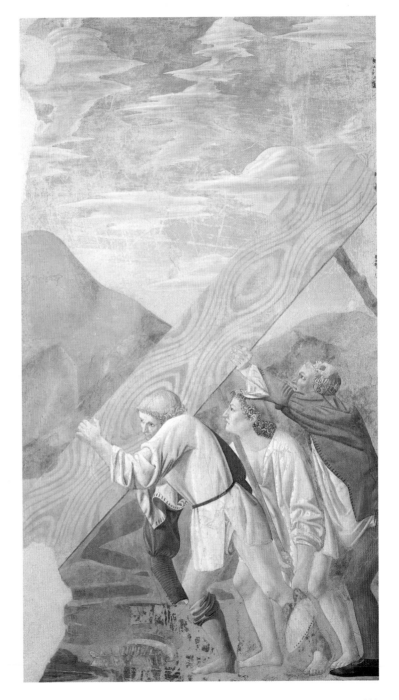

113

The Legend of the True Cross
Constantine's Dream

1452–1459
Fresco, 329 × 190 cm
Arezzo, San Francesco

The scene develops beneath the *Burial of the Wood*, in the middle register. With this scene the description shifts from the Old to the New Testament, with a shift in time that projects it into the era of Constantine.

On the eve of the battle with the barbarians of Massenzio, Constantine is worried about his enemy's superiority. In his sleep an angel appears to him revealing that should he enter into battle with the sign of the Cross and he should not fear he will lose. Constantine sleeps in a tent that is a perfectly cylindrical geometric volume that Piero had already studied carefully with his brush in the reliquary of his *Santa Maria Maddalena* and in the baldachin of his *Madonna del parto*.

The glimpse of the angel is a masterpiece, as is the back-lighting of the soldier on the left. One of its precedents is *The Angelic Announcement to the Shepherds* by Taddeo Gaddi in the Baroncelli chapel in Santa Croce in Florence. The power of the contrasts recalls Masaccio, and the play on light prefigures Raphael's *Liberation of Saint Peter from Prison*. The prodigal atmosphere is accentuated by the young man seated at the foot of Constantine's bed: his gaze, his pose, and his indifference to the miracle in act create a powerful effect of estrangement that is typical of Piero's poetry, and its offspring would come down through the painting of the novecento in all its metaphysical strength. Defined in nearly all literature as a nocturnal painting, this work is considered a dawn painting by Bertelli. Recent restoration has made it possible to decipher a dawnlike light in the chromatic values, particularly in the sky, against which the black cusps of the tents of the encampment stand out.

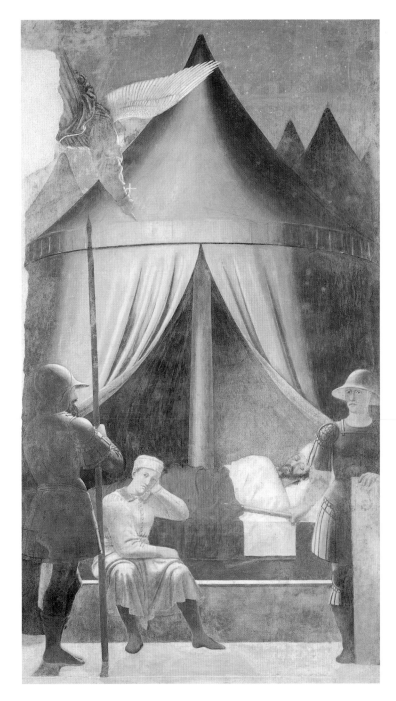

The Legend of the True Cross
The Battle of Constantine and Massenzio

1452–1459
Fresco, 322 × 764 cm
Arezzo, San Francesco

This scene is the direct sequel to *Constantine's Dream*. Constantine's army proceeds triumphant behind the emperor who raises up before him the Cross brought to him by the angel the previous night. Massenzio's army is depicted at the moment of the confused retreat in which soldiers fell into the river from the Milvian bridge that Massenzio himself had damaged. Nonetheless the battle lacks any vicious or agitated aspects: Constantine's army carries out a kind of triumphal march in the sign of the Cross. The only dynamic element in the narration is the soldier on horseback who appears to be heading toward the spectator brandishing his sword and hurling a war cry, the only true hint of brutality in the scene. The lances pointing skyward suggest a multitude of soldiers, while the banners wave in the sky in their chromatic strength of solid colors painted in a compact manner.

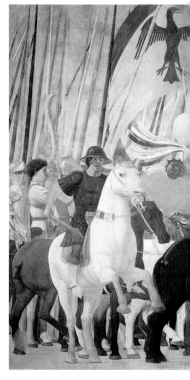

The detailing of the armor is minute. The advance of Constantine's soldiers and their black and white horses is majestic, like the pieces on a chessboard. To the right, all that remains of the defeated soldiers is the downcast gaze of a young man who invokes the sky, the white horse upon which a knight turns to look at the

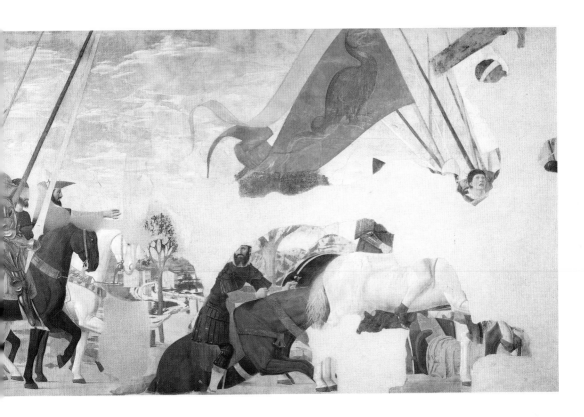

yield (his steed's ribcage, thin from suffering, and the rider's ruined footwear worn out by use all attest to the defeat). The only soldier in Massenzio's army who remains unscathed is the man on horseback emerging from the river who turns backward with an expression of fear. He grips the horse's mane with his hand.

The landscape is splendid with its view of what all believe to be the Tiber Valley and the river's clear water in which trees and houses are reflected from its banks.

The Legend of the True Cross
Torment of the Jew

1452–1459
Fresco, 356 × 193 cm
Arezzo, San Francesco

The narration continues on the rear wall, in the same register as the *Burial of the Wood*. At the end of the victorious battle of the Milvian bridge, Constantine converts to Christianity, permitting open practice of the Christian faith, and decides to look for the relic of Christ's Cross to bring it back to Constantinople, where he has transferred his court. He entrusts this task to his mother Elena, who has always been a Christian. Elena summoned the Jews to find out where Christ's Crucifix was. Judas was presented to her as the only one who knew the precise location, but since he refused to reveal its location to her, she ordered him to be thrown into a dry well where he was tortured through starvation. After six days of torture, on the seventh he asked for mercy and to be pulled out, and showed her the Cross. The moment described by Piero is that in which the Hebrew, having decided to speak, was drawn from the well.

The rendering of the curls of hair does not show the same modulation as the heads of hair that are typical of Piero's style. This detail confirms the presence of other hands, among which Longhi cites Giovanni di Piamonte.

The beams, now deprived of color, describe the triangular architecture within which the actors in the story are placed. The cartoons, certainly drawn by Piero and used by his helpers, construct solid, geometric figures, whose abstracting vocation once again gives way to the freshness of a concrete, popular sense that reveals the everyday quality of the work.

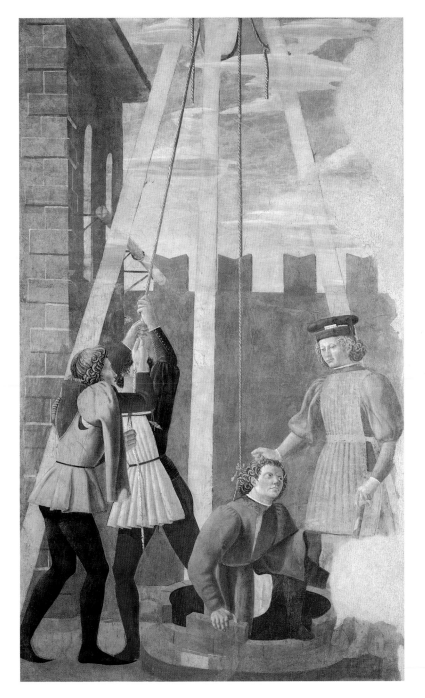

The Legend of the True Cross
Discovery of the Three Crosses and Proof of the True Cross

1452–1459
Fresco, 356 × 747 cm
Arezzo, San Francesco

The work unfurls in the left-hand wall of the chapel, in the middle register. Elena wants to find the True Cross. Judas guides the royal procession on Mount Golgotha, where, however, the crosses of the two thieves are also unveiled: in order to identify that of Christ, Elena waits for a divine sign. A miracle occurs: the Cross revives a youth. Piero depicts Jerusalem as a medieval town with a splendid view of Arezzo. The queen is depicted in both scenes wearing a black robe and a gold crown that is cone-shaped, which is fairly common in Tuscan painting. At the center a figure depicted from behind wears a turban as he comes out of the hole dug to recover the Cross. According to Carlo Bertelli the person dressed in red with a white headdress who seems to be overseeing the works could be a portrait of Piero.

At right, the urban scene is rich with architectural descriptions: the vanishing perspective of the street to the right reproduces a view of Sansepolcro. At the center of the scene, the palace with its classic shapes and perfect geometry outlined by the polychrome marbles could be, according to legend, the temple of Venus under which the three crosses of Calvary were hidden, or else the Christian church that grew out of it. Perspective, now a part of Piero's repertory, is also

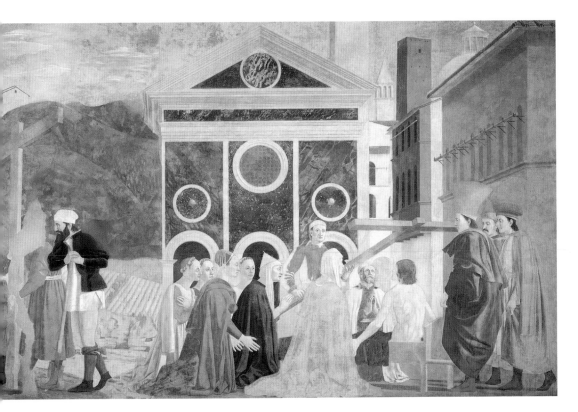

offered here in the view of the Cross held over the young man. Piero offers a precise, naturalistic description of the latter in his attempt to produce a real physical human quality that is emphasized by the shadows cast on the ground. The figures are arranged in a circle, the way the painter preferred in other compositions as well. The neatness of the draftsmanship, the airiness of the layout, and the always solid and compact coloring are the guidelines of an extremely elegant scenario that is perfectly calibrated, with a true formal purity.

The Legend of the True Cross
The Battle of Heraclius and Chosroes

1452–1459
Fresco, 329 × 747 cm
Arezzo, San Francesco

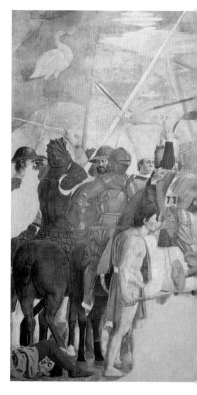

This work is located in the lower register of the left wall, facing the victory of Constantine. The story line repeats itself three centuries later: in 628 AD Persian king Chosroes purloins the Cross from Jerusalem to use it as a decoration on his throne. Challenged by the Byzantine Christian Heraclius, he is defeated and decapitated. On the right is the decapitation of Chosroes: the gold baldachin becomes a symbol of the paganism of the king who wanted to challenge the Christian God. Heraclius comes up alongside Chosroes wearing a red helmet and carrying a golden scepter, the symbol of recently attained victory.

The scene, contrary to the *Battle of Constantine and Massenzio*, is not schematically divided in two parts: here the two armies battle in a crowd engaged in impassioned hand-to-hand combat, spatially positioned on different planes. The lances are crossed, the bodies throng the space, filling it with an exorcism of *horror vacui* typical of the battle scenes depicted on Roman sarcophagi. As usual, the warriors pay homage to Rome with their classical armor in a clear reference to Trojan's column. The scene is filled with bloody valor, and Piero almost seems to focus on it, lingering in the detail. The bodies are modeled with the usual

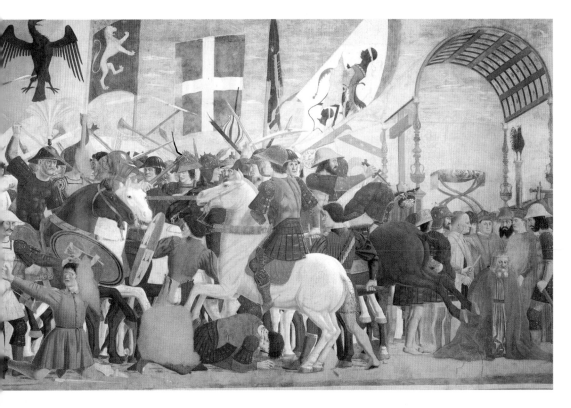

geometry, the poses are classical, and the reference that is
chronologically closest to this painting is Paolo Uccello's *Battle of
Saint Romano*. The standards flap with the familiar solidity of color
and on the right we recognize a Chosroes who is modeled after the
same figure as God in the nearby *Annunciation*. The work is the
expression of that nearly indefinable balance with which Piero
succeeds in harmonizing movement and measure in an effect of
extreme theatricality.

The Legend of the True Cross
The Exaltation of the Cross

1452–1459
Fresco, 390 × 747 cm
Arezzo, San Francesco

The scene opens in the lunette on the left-hand wall with the triumphal entry into Jerusalem of the Cross carried by Heraclius. Having arrived at the city it becomes inaccessible: an angel reminds the emperor that Christ entered Jerusalem humbly, thus Heraclius is stripped of his imperial dress and enters the Holy City unshod. The citizens kneel down before the emperor's entry.

In this scene, many interventions by the master's assistants are evident. Piero's hand is, however, recognizable in the old man standing to the right of the scene, behind the group of citizens welcoming the arrival of Heraclius. His massive and patriarchal figure stands out in front of the dark, inviolable walls of the city.

The slight inclination of the Cross born by Heraclius offers an opportunity to give depth to the scene. The draperies are the umpteenth testimonial of Piero's great ability to use lighting effects to create volume.

The background is marked by a bright light that descends gradually towards the golden lights on the horizon. The perfect symmetry and the compactness of color create an elegant narrative synthesis that allows Piero to exalt the topical moments in the story, once again using the broad space on the horizon, void of details, to dramatically isolate the figures and their performance.

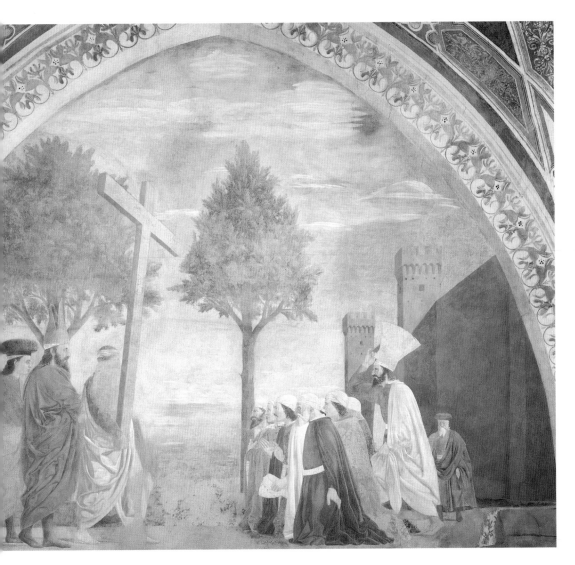

The Legend of the True Cross
The Annunciation

1452–1459
Fresco, 329 × 190 cm
Arezzo, San Francesco

Symmetrically positioned with respect to *Constantine's Dream,* *The Annunciation* is not a part of the story of *The Legend of the True Cross,* but was probably added at the request of the Franciscan order. The two divine interventions confront one another, and the interpretations of the addition of the episode to the cycle vary nonetheless.

Piero's Madonna is differentiated from the classical iconography of the Madonna of the Annunciation: in fact, she does not passively undergo the angel's Annunciation, rather she is imposing and calm as she greets the angel. The Virgin is caught while reading a prayer book in which she marks a page with a finger in order to go back to it after the Visitation, in a rendering that is extremely realistic. The bust of the Eternal Father appears above a cloud. Extending his hands down to the Virgin, he sends her the Holy Spirit in the form of golden rays of light by which the Incarnation will take place: his physiognomy is the same as that of Chosroes, and, in fact, the same cartoon was used.

The architecture is expressed in all its Renaissance glory as regulated by Alberti's doctrines and the mathematical harmony of proportions. The setting recalls a Roman house, the tiles on the floor are depicted in a vanishing perspective, in the same way that the checkered pattern behind the Madonna is a mathematical exercise. The column is once again a central dividing element.

The Eternal Father and the Virgin are solid volumes of color, while the annunciating angel, with its pose in a profile, seems to pay visual homage to fourteenth-century tradition.

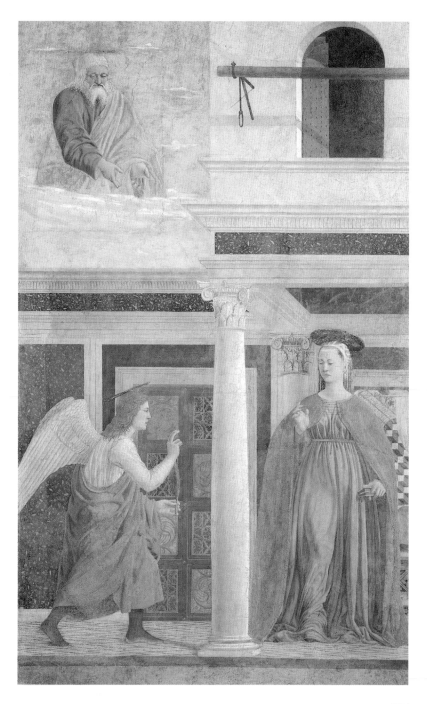

The Flagellation of Christ

1455–1460
Tempera on panel,
59 × 81.5 cm
Urbino, Galleria Nazionale
delle Marche
On the podium step, on the
left: 'OPVS PETRI DE BVRGO
S[AN]C[T]I SEPVLCRI'

The only certainty of one of Piero della Francesca's most noted and discussed paintings is his signature, which is assured by the inscription 'opvs PETRI DE BVRGO S [AN]C[T] I SEPVLCRI' on the step of the podium upon which the figure witnessing the Flagellation is seated. The iconographic interpretation is, instead, the object of a debate in which many proposals have come, one after the other, over the years. The man seated upon the throne could be identified with Pilate, but is associated by the form of his clothes and headgear, and its down-turned brim, with John VIII Palaeologus, the Eastern emperor who came to Florence for the council of 1439. A first interpretive vein of the painting as a whole (Clark, 1951) places the work within the sphere of the plans for crusades that animated the Christian world after the fall of Constantinople in 1453. The Flagellation of Christ would refer to the humiliation of the Church as it powerlessly assisted—note the hands that have fallen defenseless on the knees of the enthroned figure and his resigned gaze—its own martyrdom and that of Christ at the hands of the Turks, who are represented here by in the figure with the turban shown from behind. In 1459 Pope Pius II called a concil in Mantua in which a new crusade is decided upon and the three figures in the foreground would appear to be discussing this. Among the few certainties are iconographic references, one of the most noted of which is Signorelli's *Flagellation*, marking the influence of Flemish painting and the Albertian postulates that regulate the composition. The scene is set under a loggia with classical architecture in the logical sequence of the powerful vanishing perspective of the floor tiles, the coffered ceiling, and the vanishing perspective of the colonnade on the right. The column divides the painting into two distinct sections. Alberti's lesson—the meeting of the two met in 1451—here enters into dialogue with Piero's purity of form that builds figures as if they were made of stone, using perfectly geometric volumes, with robust necks and feet that are heavily set on the ground, in a rarified, metaphysical atmosphere.

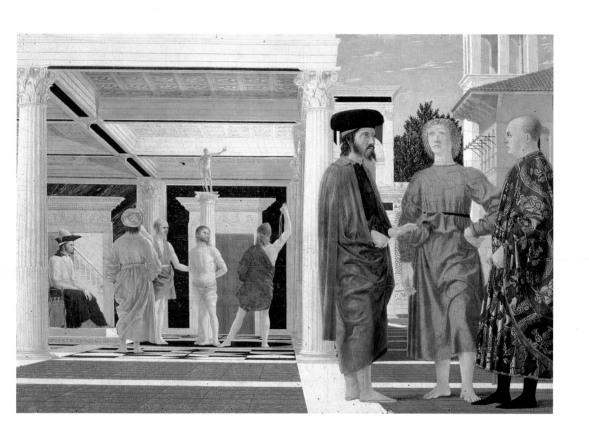

Saint Julian

1455–1460
Fresco, 130 × 105 cm
Sansepolcro, Pinacoteca
Comunale

This fragment depicts the face of a young man with a halo, identified as Saint Julian. Against a background of old green velvet, enclosed within a frame, the saint is wrapped in an elegant cape of amaranth velvet, and he gazes leftward away from the scene.

Finding an affinity between this figure of a young man and that of a prophet depicted on the right side of the rear wall of the Cappella Maggiore at the church of San Francesco, Longhi dates this work prior to the 1460s. Maetzke, on the other hand, reveals a strong affinity with the face of the angel in the center of the *Baptism*, which according to him is very similar to the head of the young Antinoos, a Roman sculpture from the third century A D.

The fresco was found on December 23, 1954, in the ancient church of Sant'Agostino in Sansepolcro, which later became the church of Santa Chiara. The isolated fragment opens the way to two considerations. The first concerns Piero's style, which is so absolutely unique and mature towards the middle of the century that it renders the authorship of the work unequivocal. The second, instead, concerns the reiteration of the same physionomic types that are invited from time to time to impersonate saints, angels, or simply men. These are figures of the absolute and their gaze, which rarely crosses that of the spectator, makes them distant, thoughtful, and transcendental in their physical and material geometric weightiness. This monumental physicality is of ancient origin and derives from models in Roman sculpture. The reference suggested by Maetzke offers an opportunity to remember Piero's trip to Rome in 1458 to fresco the rooms that would later be painted over by Raphael. The Roman references (and probably another trip to the capital in the early 1450s) enrich Piero's figurative imagination with further compositional balance.

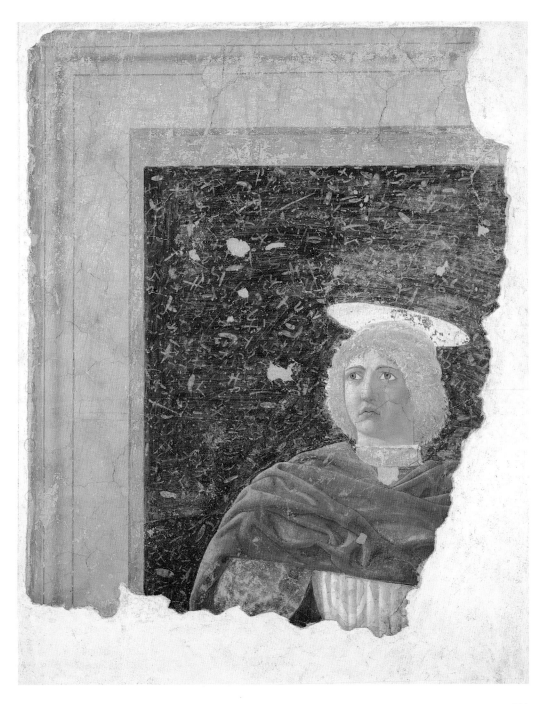

Saint Mary Magdalen

c. 1460 (date uncertain)
Fresco, 190 × 105 cm
Arezzo, Duomo

The work is located near the door to the sacristy of the Duomo in Arezzo, where Vasari points out its presence nearly hidden behind the monumental fourteenth-century cenotaph of Bishop Tarlati, who was lain here in 1783. Thus we do not know if the fresco was a part of a larger cycle or if it was made as an individual work.

The figure is characterized by elements that are typical of the iconography of Mary Magdalene: her long hair, loose on her shoulders, and the container for the unguents she spread on Christ's feet. In the West, iconography has always shown Magdalene as a beautiful woman, contrary to the image Donatello offers of her, which is that of a woman with a face marked by pain and wretched clothes. The identification of the figure of Mary Magdalene within the Gospels turns out to be remarkably complex: different episodes see a few women among the protagonists, whose names are not always mentioned. In the Latin Church, Pope Gregory the Great was the first to identify the different female figures as a single person whom he called Mary Magdalene.

Behind the saint there was likely a blue background of which only a few traces remain, just as the gold has fallen off the halo. In her hand, the saint holds a crystal reliquary whose three-dimensionality is emphasized by the perspectival effect modulating the refractions of light; a geometric solid that clearly refers to the baldachin of the *Madonna del parto*. The dignity of the volume, the delicate and ideal movement suggested by the torsion of the body away from the direction the face is looking in, and the hand attached to the arm by a very solid wrist holding the red cape, which is also heavily painted: these are the well-known elements of a composition of figures constructed within the smooth and pure geometry of color.

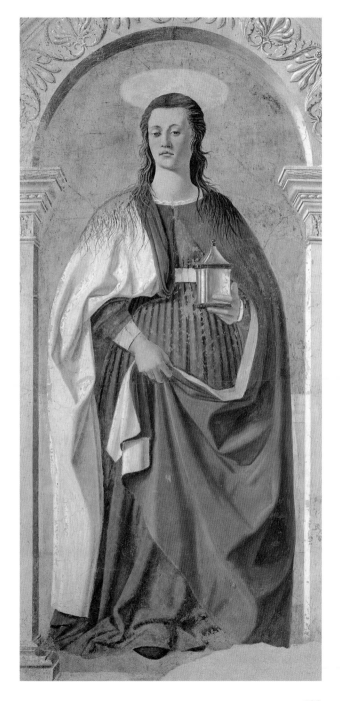

Polyptych of Saint Augustine

post-1460
Tempera and oil on panel,
132 × 56 cm
Lisbon, Museu Nacional
de Arte Antiga

This panel belongs to the *Polyptych of Saint Augustine* from the church of the Eremitani di Sant'Agostino in Sansepolcro. The reconstruction of the entire work is very complex and is possible only through philology. The central panel that would have depicted the enthroned Madonna is missing. The only certain information for reconstructing the polyptych is the position of the panels with the four saints. Alongside the central panel are *Saint Michael* to the left and, to the right, *Saint John the Evangelist* (behind the two figures are the far ends of the podium upon which the enthroned Madonna was to rest); on the far sides, *Saint Augustine* was to the left and to the right was *Saint Nicholas of Tolentino*.

The dismemberment of the polyptych took place in 1555, when the convent went into the hands of the Poor Claires, and the church had to be torn down for military defense purposes. In 1680 the four panels with saints were found in the house of Luca and Francesco Bucci, brothers of an illustrious family of Sansepolcro.

The figure of Saint Augustine, the saint who lends his name to the eponymous order of monks who commissioned this work, is the work that is very rich in detail and minute painterly descriptions that liken Piero's style irrefutably to Flemish art. The evangelical scenes embroidered on the Saint's robe are, on the left, the *Annunciation*, *Nativity*, *Flight into Egypt*, *Presentation at the Temple*, and the *Sermon on the Mount*; on the right are the *Flagellation* and *Crucifixion*.

The saint's miter is embroidered with pearls and bears a Christ carrying the cross in its center and a series of figures of saints in *aediculae* on the lower band to either side of a garish jewel. The pastoral staff in the saint's hand is of rock crystal and is a splendid example of material preciosity and refined technical exercise.

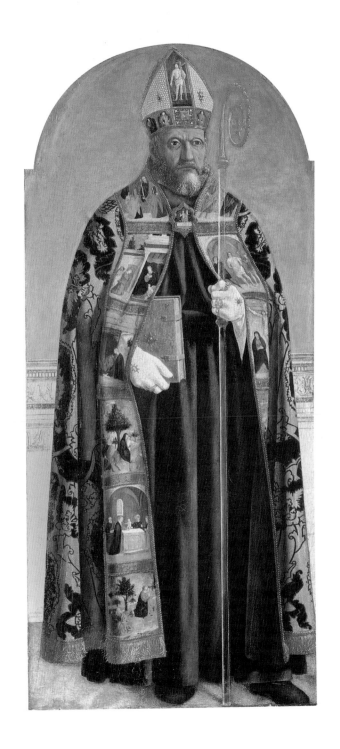

Polyptych of Sant'Agostino
Saint Nicholas of Tolentino

post-1460
Tempera and oil on panel,
136 × 59 cm
Milan, Museo Poldi Pezzoli

The dating of the polyptych is certain because all the documents concerning the work have been recovered. The contract was drafted on December 4, 1454, at the sacristy of the church of Sant'Agostino: in the text Piero is entrusted with the job of painting, decorating, and gilding a picture with figures, painting, and ornaments already agreed upon.

The patron of the polyptych is Angelo di Giovanni di Simone da Borgo and the compensation for the work was set at 320 florins. The panels were already prepared and Piero worked to complete the piece within eight years. We know that the last payment was made on May 21, 1470, and we can thus also deduce that even in this case Piero did not postpone the delivery date by very much.

The panel with Saint Nicholas is now at the Museo Poldi Pezzoli in Milan. The humanity that characterizes the saint is somewhat unusual for Piero, and makes one think of a portrait of one of the Augustinian friars that the artist met while he was making the work. The creation of a particular human typology seems to give way to the taste for a new human character that would enter his figurative repertory. While the other saints in the polyptych belong to typological constructions that had already been experimented with extensively, in this case we find ourselves facing an unusual physiognomy that leads to the hypothesis of a portrait done from life. The saint is created out of an elegant, geometric mass that is extremely solid. The solidity is guaranteed by the chiaroscuro that sculpts the form. Of particular interest is the taste for minute detail that was evidently developed through the observation of Flemish painting.

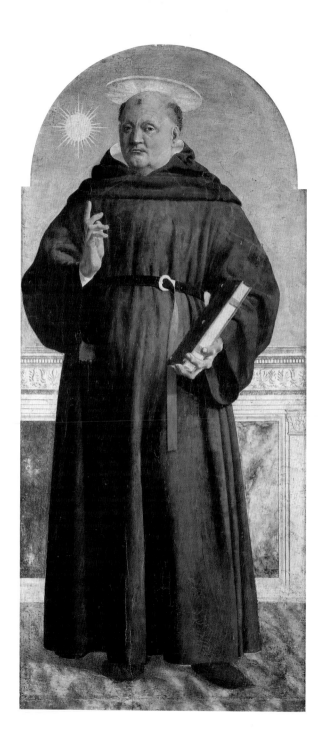

137

Madonna and Child Enthroned with Four Angels

1460–1470
Panel, 42 × 21 cm
Williamstown (Mass.),
Clark Art Institute

This work was attributed to Piero by Longhi in 1942 following a careful analysis. Chronology places it in the artist's Urbino period, close to the date of the diptych, and between the fourteen-sixties and seventies. An earlier date has also been proposed (Hendy) that is closer to the Rimini fresco because of the architectonic affinities between the two works. Gnoli made this observation in 1930 when an American collector bought it from the antiquarian Knoedler in Paris and had "no intention of sharing the pleasure of the painting with others." This is why no further examination of the painting was possible until the work reached its current home.

As for iconography, it should be noted that the Madonna is offering a red rose, apparently white due to the reflection of light, to the Child sitting on her lap, with a symbology that alludes to the Passion of Christ. Another interesting element from an iconographic point of view is the angel to the right indicating the Child, a detail that is unique among Piero's well-known works.

The Madonna is seated on a throne resting on a base whose ornate decoration with rosettes recalls Florentine style's charm. The red frieze in porphory is the same color as the drapery in the background that is reflected on either side of the Madonna, and has a garland that accentuates the depth of the scene. Around the Madonna the angels are lined up in a semicircle, composed and sober in their usual sculptural quality. The work's "noble destination" (Longhi) was revealed by the theme's "royal" interpretation: the relationship between the figures and the architecture, in fact, proves to be particularly studied (De Vecchi).

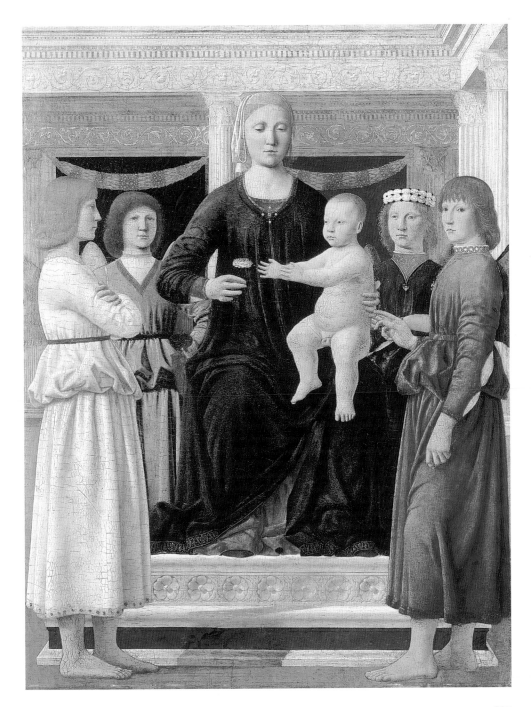

Hercules

c. 1470
Fresco, 151 × 126 cm
Boston, Isabella Stewart
Gardner Museum

Hercules represents the only pagan known to us in Piero's works. The fresco was found between 1869 and 1870 at Palazzo Graziani in Borgo Sansepolcro, in what was recognized as the home of Piero, under a layer of plaster in a room on the first floor above a door next to the fireplace.

The image is incomplete because the lower part of the fresco was destroyed when a door was cut in the eighteenth century. Longhi interpreted it as part of a cycle of illustrious men, but recent examination of the walls have shown that it is an isolated figure. The frontal pose recalls the young unshod man in the *Flagellation*, with his decisive, melancholic gaze directed heroically outward. Hercules is created in a compact volume lit by a strong light from the left. Wrapped in lion's skin, as was the custom according to tradition, he pushes the club he holds in his right hand outside the area of the painting. According to Franceschi Marini (1902) the choice of theme a from the legend according to which Monterchi, the native town of Piero's mother, was freed from a dragon thanks to the intervention of Hercules.

A *Hercules* in the Palazzo dei Conservatori in Rome has been proposed as a model. According to Maetzke, the work was made in the seventies. The figure, thematically isolated within Piero della Francesca's oeuvre, once again offers an example of the master's love for the human figure sculpted out of volume and light. The line defining the body does not linger over anatomic details, the definition of which is instead entrusted to the effects of chiaroscuro that smooth over the surfaces.

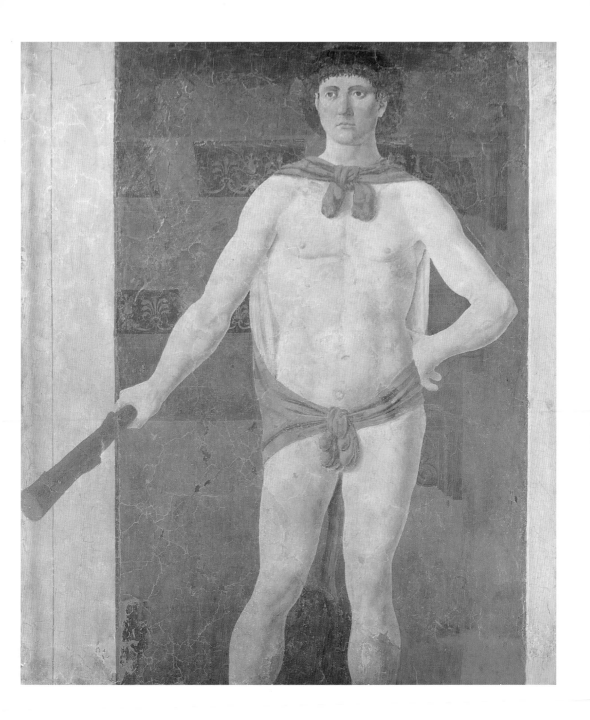

Madonna with Child, Six Saints, Four Angels and Duke Federico II da Montefeltro (Brera Altarpiece)

c. 1472–1474
Tempera on panel,
248 × 170 cm
Milan, Pinacoteca di Brera

The scene is set within a large marble temple with the characteristics of a Roman monument from the imperial age. It is a church of Albertian inspiration and the figures are arranged in a semicircle in the transept, in front of the apse, and each is framed by an architectural element. The choir is portrayed by a barrel vault with lacunaria and concludes in a semicircular apse surmounted by a large shell. At the center of the composition, the Madonna is seated on a gilded faldstool and the Child lies sleeping on her legs. The saints are commonly recognized as: Saint John the Baptist, Saint Bernardine of Siena, and Saint Jerome to the left; Saint Francis, Saint Peter Martyr, and Saint John the Evangelist to the other side. The penultimate figure on the right has been identified as Fra' Luca Pacioli. Kneeling in the foreground in profile is Federico II da Montefeltro, the painting's patron.

The work's symbology is complex: the shell and egg have been interpreted variously, but the most common hypothesis associates the egg with the incarnation of Christ. As for stylistic aspects, the architecture, a perfect transposition of Alberti's postulates, becomes space and converses with the figures within it in a modern manner that is somehow natural and yet highly calculated. The work deserves particular attention to the play on light created by the shadow of the shell in the apsidal vault. Mathematical perspective is exercised within the view of the vault and the geometric design on the cloth upon which the Madonna's feet rest. It must also be observed, with respect to the essentiality of the previous works, how he lingers over details such as the preciousness of the Virgin's clothes, and jewels, and the four angels behind her. A sacra conversazione becomes a court celebration of the political and military power of the Montefeltro family. Elegance, silence, and enchantment are the constants in Piero's art that here appears to measure the balance between its own essentiality, a thoroughly Flemish naturalism, and a taste for detail.

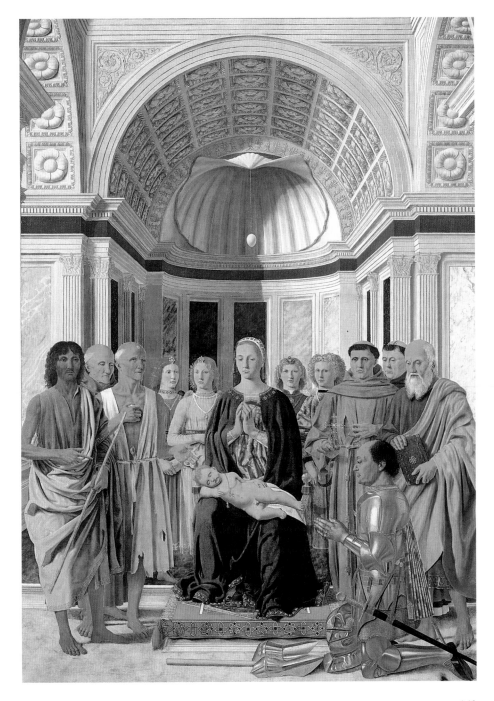

143

The Nativity

c. 1472–1474
Oil on panel,
124.5 × 123 cm
London, National Gallery

This is probably one of Piero's final paintings, but the dates are not certain. It is the work that is closest to that Flemish style, that he appreciated during his trips between Rimini and Urbino, similar to the northern manner of representation. The painting is considered incomplete because of the many missing parts. Most scholars, including Longhi, agree to date it to around 1470.

The Child lies on the ground as is typical in northern iconography: a strong similarity with the Child by Hugo van der Goes in the *Portinari Tryptych* at the Uffizi was observed. The Madonna, with her soft and subtle forms and very elegant ivory figure, contemplates the child as he lies on part of her mantle. Saint Joseph, to the right, sits on his saddle, in a pose that has an almost domestic, absolutely intimate flavor to it. Behind him one of the shepherds points skyward, probably towards the star of Bethlehem. A group of music-making angels on the left closes the foreground of the composition. None of their instruments show signs of strings.

Behind them a landscape opens up that also has a northern feel to it. There are many naturalistic inserts that betray a Flemish taste in the treatment of the subject, above all in the precious detail of the Madonna's dress and of the angels standing behind her. On the whole it is a more intimate, picturesque composition, but it does not betray the monumental vocation in the typical sculptural substance of the figures, which is barely hesitant in the face of the Virgin, with her pointed, delicate features offset by her solid wrists. There is barely a suggestion of architecture in the ruins or in the background where Borgo Sansepolcro is depicted. To the left, the space is punctuated by the landscape and riverbend in which the trees are reflected in a luminous opening that is attentive to naturalistic detail.

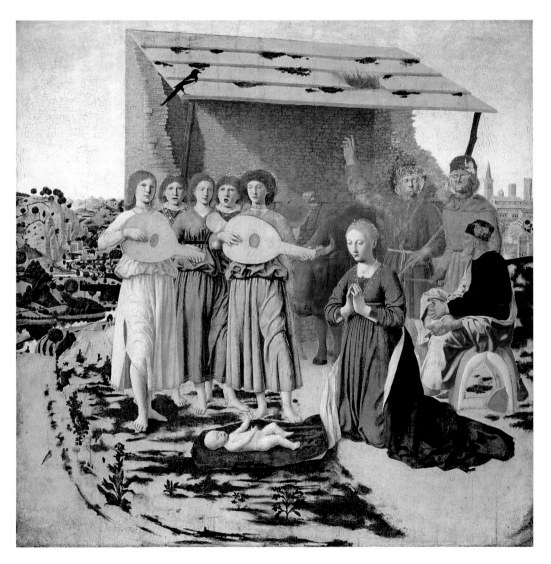

Virgin with Child Giving His Blessing and Two Angels (The Senigallia Madonna)

1472–1475
Oil on panel, 61 × 53.5 cm
Urbino, Galleria Nazionale
delle Marche

The majority of critics, for lack of elements providing certitude, support a late date: for Longhi and De Vecchi 1470, 1472–1475 for Clark, and 1478 according to Battisti. It is presumed that the small painting was commissioned by Federico da Montefeltro on the occasion of the marriage, celebrated in 1478, of his daughter Giovanna with Giovanni della Rovere, Lord of Senigallia. The work was made for the church of Santa Maria delle Grazie *extra moenia* in Senigallia, and is now at the Galleria Nazionale delle Marche in Urbino. As far as concerns its execution, an oil medium was used to spread the color on a walnut support, confirming Piero's attention to Flemish painting in the latter part of his life even from a technical point of view.

The Madonna holds the Child in her arms in an atmosphere of extreme meditation. Behind her on the shelves are a container and a basket: the first should hold the host and thus allude to the Madonna's purity and role as a savior as she welcomes Jesus into her womb, and the basket protected Moses.

According to Longhi, the work handles the "monumental and the intimate", the two boundaries between which his poetry manifests itself. The construction of the volume of the bodies, the composure of the figures, and the sobriety of the costumes, which nonetheless lend themselves to the elegance of the angels's jewels and to the refined transparency of the Virgin's headcovering, are all monumental. The atmosphere of this interior of a fifteenth-century house is intimate, almost domestic. The architecture shown in the light entering at the left allows Piero to work on lighting effects, a clear reference to the Flemish world. Nonetheless Piero maintains a certain distance from that style, that is precisely the monumentality, the sobriety of shapes, and a detail that is never overly investigated or refined on its own. On the whole, the work appears clean, essential, and fixed in that static silence that is the charm of Piero della Francesca's manner.

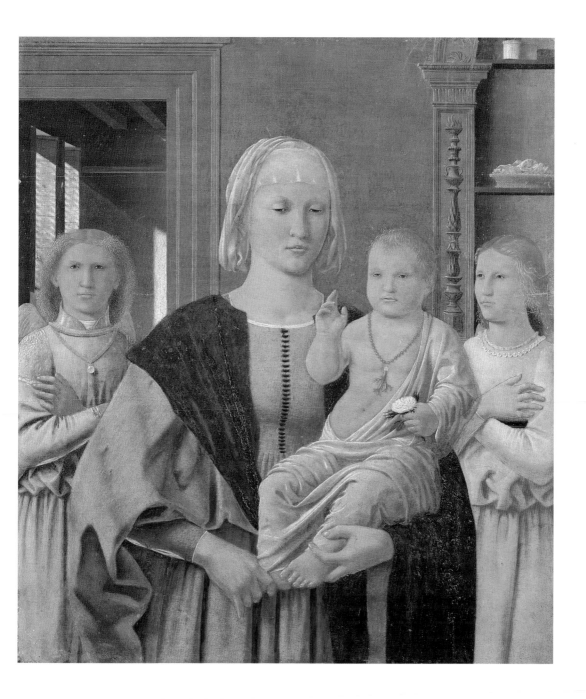

Diptych of the Duke and Duchess of Urbino
Portrait of Federico da Montefeltro

c. 1474

Oil on panel, 47 × 33 cm
Florence, Galleria degli Uffizi

This portrait of Federico is one of the most famous paintings in the history of art. It has often been associated with the idea of the Renaissance itself, probably because it celebrates man as the active protagonist of history. The Duke of Urbino was just that for many reasons: able to gather around him the most coveted artists of the period, and able to transform Urbino into a capital of art and culture. His physiognomy is the one that is firmly entrusted to tradition and proposed again in the *Brera Altarpiece*. His olive skin is furrowed by a network of wrinkles; his nose in no way camouflages the aquiline profile conferred upon him by an accident during a tournament when he was young, which also cost him his right eye. The way Piero dwells on the defects of his skin is extremely naturalistic; the duke is an earthly creature.

Federico wears the red ducal robe, symbol of his rank, and his bright red cylindrical headgear stands out against the backdrop of blue sky. Even in this case Piero again suggests a descriptive element as an expedient for inserting a detail of perfect geometry that strongly abstracts the composition.

The most immediate models are the portraits of the Este family by Pisanello, from which Piero borrowed the taste for linear constructions of the figure against empty spaces. The pose is decisive; his gaze nonetheless transmits benevolence in addition to determination. The red erupts in the painting and stands out against the background in a decisive manner. The duke is drawn as if he were on a different plane from that of the landscape, on a plane that is closer to the viewer. In the background, the very modern landscape once again reflects a Flemish influence.

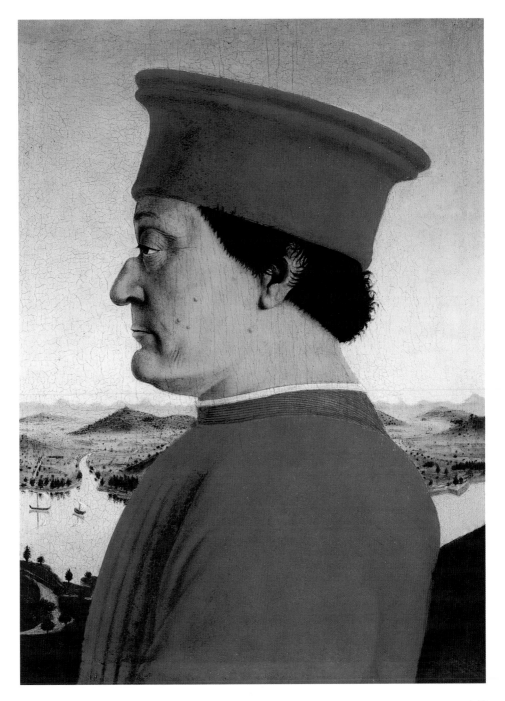

Diptych of the Duke and Duchess of Urbino
Portrait of Battista Sforza

c. 1474
Oil on panel, 47 × 33 cm
Florence, Galleria degli Uffizi

On the left panel of the diptych, Federico had his wife Battista portrayed. Painted on both sides, the two paintings were originally joined by hinges and closed like a book. The diptych, once in the Urbino palace, probably in the audience chamber, came to Florence in 1631 with the Della Rovere inheritance upon the extinction of the ducal house, and thus came to the Uffizi, its current location.

The woman is portrayed in profile, in keeping with ancient numismatic tradition; behind her a wide bird's-eye-view of a landscape opens up that is depicted in the style of Flemish painting. Here, the problem of the infinitely distant and infinitely near is resolved in a harmonious naturalistic rendering, warmed with color, in an homage to Domenico Veneziano.

Battista's pale face is framed by a sophisticated hairstyle in which a precious jewel is set and from which a light white veil swells in a complex play of folds. The duchess's precious jewels are intensely highlighted. Her very white, ivory face is outlined by careful line that detaches it decisively from the sky in the background. The isolation of the portrait's subjects within voids is a method typical of Piero that may be observed in *Saint Sigismondo and Sigismondo Pandolfo Malatesta* at the Malatesta temple in Rimini, among other examples. The woman looks upon her husband in a play of gazes in which there is a complacent understanding of their dominion over the lands defined behind their profiles. Elegance, linearity, and a calibrated play on detail and synthesis are the strong characteristics of one of Piero della Francesca's most noted works.

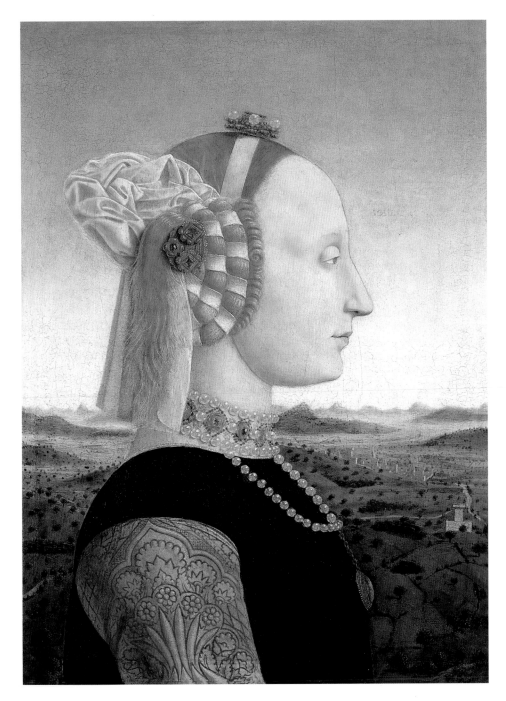

Diptych of the Duke and Duchess of Urbino
Triumph of Federico da Montefeltro

c. 1474

Oil on panel, 47 × 33 cm
Florence, Galleria degli Uffizi
Bottom: 'CLARVS INSIGNI
VEHITVR TRIVMPHO / QUEM
PAREM SVMMIS DVCIBVS
PERHENNIS / FAMA VIRTVTVM
CELEBRAT DECENTER / SCEPTRA
TENENTEM'

On the reverse side of the diptych the couple's allegorical triumphs are represented: the duke and duchess are carried on very simple carts made of wood that, when the painted panels are opened, appear to advance toward one another.

Beneath the *Triumph of Federico da Montefeltro* is a Latin inscription that celebrates the duke's skills as a leader: 'CLARVS INSIGNI VEHITVR TRIVMPHO / QUEM PAREM SVMMIS DVCIBVS PERHENNIS / FAMA VIRTVTVM CELEBRAT DECENTER / SCEPTRA TENENTEM' (That illustrious man, whose perennial fame from his virtues rightly celebrates as a bearer of the scepter, who is equal to the greatest leaders, is carried in great triumph).

The *Triumph of Federico da Montefeltro* shows him dressed in shining armor, the same as that shown in the *Brera Altarpiece*, and seated on a faldstool on a predella covered with gold cloth; the cart is covered in red cloth. Behind him stands a winged figure dressed in white who, standing upon a sphere, places a crown upon Federico's head. Before him upon the cart are the four cardinal virtues: seated frontally is Justice, holding her sword and scale; next to her, in profile, is seated Prudence, looking at herself in a mirror; Fortitude sits with the broken column and, finally, seen from behind, sits Temperance. The cart is pulled by two white horses. Among the interpretations that should be pointed out is Lightbown's, which identifies the figure standing behind Federico as Fortuna.

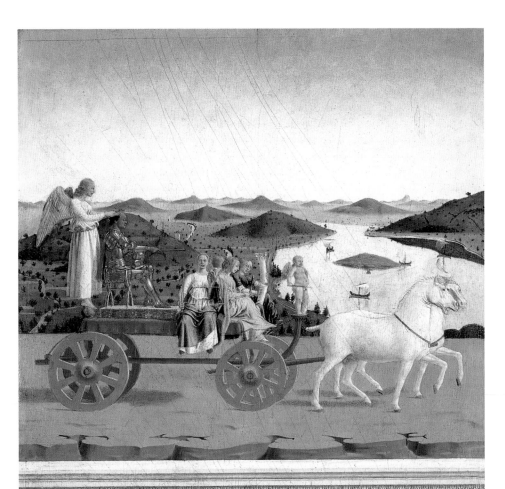

CLARVS INSIGNI VEHITVR TRIVMPHO ·
QVEM PAREM SVMMIS DVCIBVS PERHENNIS ·
FAMA VIRTVTVM CELEBRAT DECENTER ·
SCEPTRA TENENTEM ⁓

Diptych of the Duke and Duchess of Urbino
Triumph of Battista Sforza

c. 1474

Oil on panel, 47 × 33 cm
Florence, Galleria degli Uffizi
Bottom: 'QVE MODVM REBVS
TENVIT SECVNDIS / CONIVGIS
MAGNI DECORATA RERVM
/ LAVDE GESTARVM VOLITAT
PER ORA / CVNCTA VIRORVM'

The inscription running along beneath this triumph, as in Federico's panel, celebrates the figure of the duchess: 'QVE MODVM REBVS TENVIT SECVNDIS / CONIVGIS MAGNI DECORATA RERVM / LAVDE GESTARVM VOLITAT PER ORA / CVNCTA VIRORVM' (She who keeps moderation in favorable circumstances is on the lips of all men, adorned with praise for the acts of her husband).

The cart is pulled by two unicorns, a symbol of chastity. Even the duchess is seated upon a gilded faldstool resting on a predella covered over with a rug with gold woven into it; the cart is green. The duchess wears a red gown with golden sleeves and carries a prayer book. On the cart are the feminine virtues, perhaps Chastity and Temperance, in front of whom are seated Charity with the pelican and, towards the spectator, Faith, dressed in red holding a chalice and the Host in her hand.

Here the recuperation of antiquity becomes a celebration shown before a landscape that for its chromatic and tonal values represents one of Piero's highest achievements in painting.

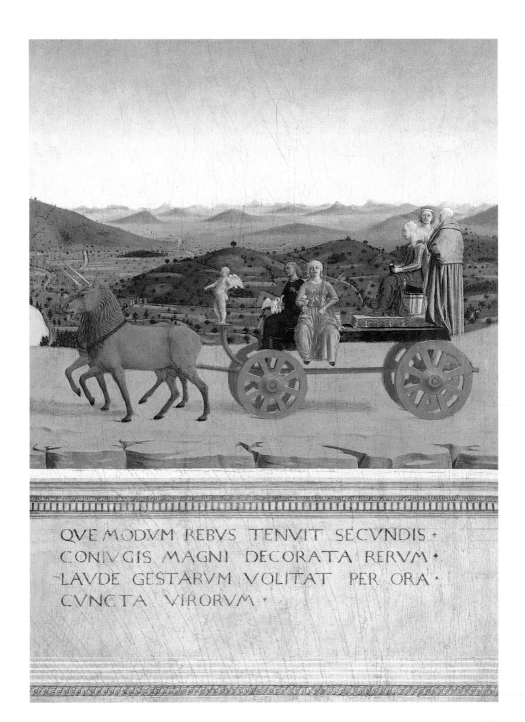

QVE MODVM REBVS TENVIT SECVNDIS ·
CONIVGIS MAGNI DECORATA RERVM ·
LAVDE GESTARVM VOLITAT PER ORA ·
CVNCTA VIRORVM ·

Appendix

Chronological Table

	The Life of Piero della Francesca	Historical and Artistic Events
1370		Charles V gives Borgo Sansepolcro to the Church, which sells it in the same year to Galeotto Malatesta of Rimini.
1416	Marriage of Benedetto di Pietro del Borgo de' Franceschi and Romana di Perino di Carlo da Monterchi: the artist is their first-born.	
1420	Terminus *post quem* of Piero della Francesca's birth.	Pope Martin V makes his solemn entry into Rome. Brunelleschi realizes a model in masonry for the cupola of Santa Maria del Fiore in Florence.
1430		Borgo Sansepolcro goes back into the hands of Martin V. Sassetta begins the *Polyptych of the Madonna of the Snow*.
1435	Piero begins his apprenticeship in Florence with Domenico Veneziano: during this period he may have traveled with the master to the Marches and Umbria.	Niccolò da Tolentino dies. Compilation of the Latin text *De pictura* by Leon Battista Alberti.
1439	On September 7 payment is mentioned for the frescoes in the church of Sant'Egidio commissioned by the Spedale di Santa Maria Nuova in Florence.	The ecumenical council of Ferrara is moved to Florence. Donatello completes the choir of Santa Maria del Fiore.
1440		Borgo Sansepolcro is ceded to Florence. Masolino dies.
1445	Commission of the *Polyptych of the Misericordia* at Borgo Sansepolcro. He probably begins to frequent the court at Urbino.	Domenico Veneziano interrupts the frescoes at Sant'Egidio and finishes the pala at Santa Lucia de' Magnoli. Botticelli is born.
c. **1450**	Paints *Saint Jerome* and a Donor.	Alberti begins work on the Malatesta Temple at Rimini.
1451	The date is written into the fresco of *Saint Sigismondo and Sigismondo Pandolfo Malatesta* at the Malatesta Temple. He meets Leon Battista Alberti.	
1452	He takes over the work of Bicci di Lorenzo in the execution of the frescoes for the church of San Francesco at Arezzo.	Frederick III is crowned Italy Roman Emperor. Lorenzo Ghiberti completes the Gates of Paradise. Bicci di Lorenzo dies. Leonardo da Vinci is born.

The Life of Piero della Francesca	Historical and Artistic Events
1454 October 4: contract for the *Polyptych of Saint Augustine*, painted after 1460. Shortly thereafter he is summoned by Pope Nicholas V to make the frescoes for Santa Maria Maggiore, of which only a few fragments remain.	Peace of Lodi. Agnolo Poliziano is born.
1459 He is back in Rome, probably to realize some works for Pius II.	Benozzo Gozzoli starts making the fresco of the *procession of the Magi*. Mantegna completes the *San Zeno Altarpiece*.
1460 Terminus *post quem* for the execution of the *Flagellation of Christ*.	Alberti begins the construction of the church of San Sebastiano in Mantua.
1467 At Borgo Sansepolcro he holds public office.	
1472 Between 1472 and 1474 he probably paints the *Brera Altarpiece*.	Federico da Montefeltro conquers Volterra. Leon Battista Alberti dies.
***c.* 1474** Paints the panel of Federico for the *Diptych of the Duke and Duchess of Montefeltro*.	
1474 April 12 he is paid for his work at the church of the Badia in Borgo Sansepolcro.	Mantegna completes the decoration of the Camera degli Sposi.
1475	Paolo Uccello dies. Michelangelo is born.
1478 The confraternity of the Misericordia entrusts Piero with the realization of a fresco of the Madonna of which, however, no traces remain.	Giorgione is born.
1482 He is at Rimini, renting a house from Giacosa, widow of Ganimede Borelli.	Leonardo is in Milan at the court of Ludovico il Moro. Botticelli paints *Primavera*.
1483	Raffaello Sanzio is born. Leonardo da Vinci receives the commission for the *Virgin of the Rocks*. Botticelli paints the *Birth of Venus between* 1483 and 1485.
1492 On October 12 his burial is recorded in Badia.	Christopher Columbus discovers America. Lorenzo the Magnificent dies in Florence and Savonarola becomes ruler.

Geographical Locations of the Paintings

in public collections

Italy

The Legend of the True
Cross
Fresco
Arezzo, San Francesco
1452–1459

The Legend of the True
Cross
The Death of Adam
Fresco, 390 × 747 cm
Arezzo, San Francesco
1452–1459

The Legend of the True Cross
The Adoration of the Holy Wood
and the Meeting of Salomon
with the Queen of Sheba
Fresco, 336 × 747 cm
Arezzo, San Francesco
1452–1459

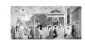

The Legend of the True
Cross
Burial of the Wood
Fresco, 356 × 190 cm
Arezzo, San Francesco
1452–1459

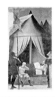

The Legend of the True
Cross
Constantine's Dream
Fresco, 329 × 190 cm
Arezzo, San Francesco
1452–1459

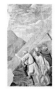

The Legend of the True
Cross
The Battle of Constantine
and Massenzio
Fresco, 322 × 764 cm
Arezzo, San Francesco
1452–1459

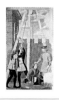

The Legend of the True
Cross
Torment of the Jew
Fresco, 356 × 193 cm
Arezzo, San Francesco
1452–1459

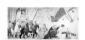

The Legend of the True
Cross. Discovery of the
Three Crosses and Proof
of the True Cross
Fresco, 356 × 747 cm
Arezzo, San Francesco
1452–1459

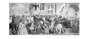

The Legend of the True
Cross
The Battle of Heraclius and
Chosroes
Fresco, 329 × 747 cm
Arezzo, San Francesco
1452–1459

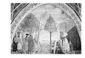

The Legend of the True
Cross
The Exaltation of the Cross
Fresco, 390 × 747 cm
Arezzo, San Francesco
1452–1459

Italy

The Legend of the True Cross
The Annunciation
Fresco, 329 × 190 cm
Arezzo, San Francesco
1452–1459

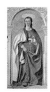

Saint Mary Magdalene
Fresco, 190 × 105 cm
Arezzo, Duomo
c. 1460 (date uncertain)

Diptych of the Duke and Duchess of Urbino
Portrait of Federico da Montefeltro
Oil on panel, 47 × 33 cm
Florence, Galleria degli Uffizi
c. 1474

Diptych of the Duke and Duchess of Urbino
Portrait of Battista Sforza
Oil on panel, 47 × 33 cm
Florence, Galleria degli Uffizi
c. 1474

Diptych of the Duke and Duchess of Urbino
Triumph of Federico da Montefeltro
Oil on panel, 47 × 33 cm
Florence, Galleria degli Uffizi
c. 1474

Diptych of the Duke and Duchess of Urbino
Triumph of Battista Sforza
Oil on panel, 47 × 33 cm
Florence, Galleria degli Uffizi
c. 1474

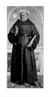

Polyptych of Sant'Agostino
Saint Nicholas of Tolentino
Tempera and oil on panel,
136 × 59 cm
Milan, Museo Poldi Pezzoli
post 1460

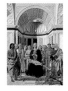

Madonna with Child, Six Saints, Four Angels and Duke Federico II da Montefeltro.
Brera Altarpiece
Tempera, 248 × 170 cm
Milan, Pinacoteca di Brera
c. 1472-1474

Madonna del parto
Fresco,
260 × 203 cm
Monterchi (Arezzo),
1450-1455

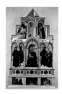

Polyptych of Sant'Antonio
Oil on panel,
338 × 230 cm
Perugia, Galleria Nazionale dell'Umbria
1450-1468

Italy

Saint Sigismondo and Sigismondo Pandolfo Malatesta
Fresco transferred on canvass, 257 × 345 cm
Rimini, Tempio Malatestiano
1450–1451

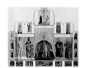

Polyptych of the Misericordia
Oil and tempera on panel, approx. 273 × 330 cm
Sansepolcro, Pinacoteca Comunale
1445–1462

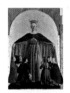

Polyptych of the Misericordia. Madonna of Mercy
Oil and tempera on panel, 134 × 91 cm
Sansepolcro, Pinacoteca Comunale
1445–1462

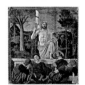

The Resurrection of Christ
Fresco, 225 × 200 cm
Sansepolcro, Pinacoteca Comunale
c. 1450

Saint Julian
Fresco, 130 × 105 cm
Sansepolcro, Pinacoteca Comunale
1455–1460

The Flagellation of Christ
Tempera on panel, 59 × 81.5 cm
Urbino, Galleria Nazionale delle Marche
1455–1460

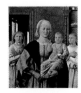

Virgin with Child Giving His Blessing and Two Angels. The Senigallia Madonna
Oil on panel, 61 × 53.5 cm
Urbino, Galleria Nazionale delle Marche
1472–1475

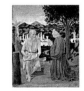

Saint Jerome and a Donor
Tempera on panel, 49 × 42 cm
Venice, Gallerie dell'Accademia
c. 1450

France

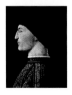

Portrait of Sigismondo Pandolfo Malatesta
Oil and tempera on panel, 44.5 × 34.5 cm
Paris, Musée du Louvre
1450–1451

Germany		*Saint Jerome Penitent* Oil on panel, 51 × 38 cm Berlin, Staatliche Museen zu Berlin, Preußischer Kulturbesitz, Gemäldegalerie 1450	
Great Britain	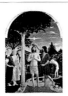	*The Baptism of Christ* Tempera on panel, 167 × 116 cm London, National Gallery *c.* 1450	*The Nativity* Oil on panel, 124.5 × 123 cm London, National Gallery *c.* 1472–1474
Portugal	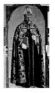	*Polyptych of Sant'Agostino* Tempera and oil on panel, 132 × 56 cm Lisbona, Museu Nacional de Arte Antiga *post* 1460	
USA		*Hercules* Fresco, cm 151 × 126 Boston, Isabella Stewart Gardner Museum *c.* 1470	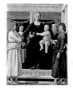 *Madonna and Child* *Enthroned* *with Four Angels* Panel, 42 × 21 cm Williamstown (Mass.), Clark Art Institute 1460–1470

Writings

PIERO DELLA FRANCESCA [*PIERO BORGHESE*]
Painter of Borgo a San Sepolcro

Truly unhappy are those who, labouring at their studies in order to benefit others and to make their own name famous, are hindered by infirmity and sometimes by death from carrying to perfection the works that they have begun. And it happens very often that, leaving them all but finished or in a fair way to completion, they are falsely claimed by the presumption of those who seek to conceal their asses' skin under the honourable spoils of the lion. And although time, who is called the father of truth, sooner or later makes manifest the real state of things, it is none the less true that for a certain space of time the true craftsman is robbed of the honour that is due to his labours; as happened to Piero della Francesca of Borgo a San Sepolcro. He, having been held a rare master of the difficulties of drawing regular bodies, as well as of arithmetic and geometry, was not yet able—being overtaken in his old age by the infirmity of blindness, and finally by the close of his life—to bring to light his noble labours and the many books written by him, which are still preserved in the Borgo, his native place. The very man who should have striven with all his might to increase the glory and fame of Piero, from whom he had learnt all that he knew, was impious and malignant enough to seek to blot out the name of his teacher, and to usurp for himself the honour that was due to the other, publishing under his own name, Fra Luca dal Borgo, all the labours of that good old man, who, besides the sciences named above, was excellent in painting.

Piero was born in Borgo a San Sepolcro, which is now a city, although it was not then; and he was called Dell Francesca after the name of his mother, because she had been left pregnant with him at the death of her husband, his father, and because it was she who had brought him up and assisted him to attain to the rank that his good-fortune held out to him. Piero applied himself in his youth to mathematics, and although it was settled when he was fifteen years of age that he was to be a painter, he never abandoned this study; nay, he

made marvelous progress therein, as well as in painting. He was employed by Guidobaldo Feltro the elder, Duke of Urbino, for whom he made many very beautiful pictures with little figures, which have been for the most part ruined on the many occasions when that state has been harassed by wars. Nevertheless, there were preserved there some of his writings on geometry and perspective, in which sciences he was not inferior to any man of his own time, or perchance even to any man of any other time; as is demonstrated by all his works, which are full of perspectives, and particularly by a vase drawn in squares and sides, in such a manner that the base and the mouth can be seen from the front, from behind, and from the sides; which is certainly a marvelous thing, for he drew the smallest details therein with great subtlety, and foreshortened the curves of all the circles with much grace. Having thus acquired credit and fame at that Court, he resolved to make himself known in other places; wherefore he went to Pesaro and Ancona, whence, in the very thick of his work, he was summoned by Duke Borso to Ferrara, where he painted many apartments in his palace, which were afterwards destroyed by Duke Ercole the elder in the renovation of the palace, insomuch as there is nothing by the hand of Piero left in that city, save a chapel wrought in fresco in S. Agostino; and even that has been injured by damp. Afterwards, being summoned to Rome, he painted two scenes for Pope Nicholas V in the upper rooms of his palace, in competition with Bramante da Milano; but those were also thrown to the ground by Pope Julius II—to the end that Raffaello da Urbino might paint there the Imprisonment of S. Peter and the miracle of the Corporale of Bolsena—together with certain others that had been painted by Bramantino, an excellent painter in his day.

Now, seeing that I cannot write the life of this man, nor particularize his works, because they have been ruined, I will not grudge the labour of making some record of him, for it seems an apt occasion. In the said works that were thrown to the ground, so I have heard tell, he had made some heads from nature, so beautiful and well executed that speech alone was wanting to give them life. Of these heads not a few have come to light, because Raffaello da Urbino had

them copied in order that he might have the likenesses of the subjects, who were all people of importance; for among them were Niccolò Fortebraccio, Charles VII, King of France, Antonio Colonna, Prince of Salerno, Francesco Carmignuola, Giovanni Vitellesco, Cardina Bessarione, Francesco Spinola, and Battista da Canneto. All these portraits were given to Giovio by Giulio Romano, disciple and heir of Raffaello da Urbino, and they were placed by Giovio in his museum at Como. Over the door of S. Sepolcro in Milan I have seen a Dead Christ wrought in foreshortening by the hand of the same man, in which, although the whole picture is not more than one braccio in height, there is an effect of infinite length, executed with facility and judgment. By his hand, also, are some apartments and loggie in the house of the Marchesino Ostanesia in the same city, wherein there are many pictures wrought by him that show mastery and very great power in the foreshortening of the figures. And without the Porta Vercellina, near the castle, in certain stables now ruined and destroyed, he painted some grooms currying horses, among which there was one so lifelike and so well wrought, that another horse, thinking it a real one, lashed out at it repeatedly with its hooves.

But to return to Piero della Francesca; his work in Rome finished, he returned to the Borgo, where his mother had just died; and on the inner side of the central door of the Pieve he painted two saints in fresco, which are held to be very beautiful. In the convent of the Friars of S. Augustine he painted the panel of the high-altar, which was a thing much extolled; and he wrought in fresco a Madonna della Misericordia for a company, or rather, as they call it, a confraternity; with a Resurrection of Christ in the Palazzo de' Conservatori, which is held the best of all the works that are in the said city, and the best that he ever made. In company with Domenico da Venezia, he painted the beginning of a work on the vaulting of the Sacristy of S. Maria at Loreto; but they left it unfinished from fear of plague, and it was afterwards completed by Luca da Cortona [Luca Signorelli], a disciple of Piero, as will be told in the proper place.

Going from Loreto to Arezzo, Piero painted for Luigi Bacci, a citizen of Arezzo, the Chapel of the

High-altar of S. Francesco, belonging to that family, the vaulting of which had already begun by Lorenzo di Bicci. In this work there are Stories of the Cross, from that wherein the sons of Adam are burying him and placing under his tongue the seed of the tree from which there came the wood for the said Cross, down to the Exaltation of the Cross itself performed by the Emperor Heraclius, who, walking barefoot and carrying it on his shoulder, is entering with it into Jerusalem. Here there are many beautiful conceptions and attitudes to be extolled; such as, for example, the garments of the women of the Queen of Sheba, executed in a sweet and novel manner; many most life-like portraits from nature of ancient persons; a row of Corinthian columns, divinely well proportioned; and a peasant who, leaning with his hands on his spade, stands listening to the words of S. Helena—while the three Crosses are being disinterred—with so great attention, that it would not be possible to improve it. Very well wrought, also, is the dead body that is restored to life at the touch of the Cross, together with the joy of S. Helena and the marveling of the bystanders, who are kneeling in adoration. But above every other consideration, whether of imagination or of art, is his painting of Night, with an angel in foreshortening who is flying with his head downwards, bringing the sign of victory to Constantine, who is sleeping in a pavilion, guarded by a chamberlain and some men-at-arms who are seen dimly through the darkness of the night; and with his own light the angel illuminates the pavilion, the men-at-arms, and all the surroundings. This is done with very great thought, for Piero gives us to know in this darkness how important it is to copy things as they are and to ever take them from the true model; which he did so well that he enabled the moderns to attain, by following him, to that supreme perfection wherein art is seen in our own time. In this same story he represented most successfully in a battle fear, animosity, dexterity, vehemence, and all the other emotions that can be imagined in men who are fighting, and likewise all the incidents of battle, together with an almost incredible carnage, what with the wounded, the fallen, and the dead. In these Piero counterfeited in fresco the glittering of their arms,

for which he deserves no less praise than he does for the flight and submersion of Maxentius painted on the other wall, wherein he made a group of horses in foreshortening, so marvelously executed that they can be truly called too beautiful and too excellent for those times. In the same story he made a man, half nude and half in the dress of a Saracen, riding a lean horse, which reveals a very great mastery of anatomy, a science little known in his age. For this work, therefore, he well deserved to be richly rewarded by Luigi Bacci, whom he portrayed there in the scene of the beheading of a King, together with Carlo and others of his brothers and many Aretines who were then distinguished in letters; and to be loved an revered ever afterwards, as he was, in that city, which he had made so illustrious with his works.

In the Vescovado of the same city, also, he made a S. Mary Magdalene in fresco beside the door of the sacristy; and for the Company of the Nunziata he painted the banner that is carried in processions. At the head of a cloister at S. Maria dell Grazie, without that district, he painted S. Donatus in his robes, seated in a chair drawn in perspective, together with certain boys; and in a niche high up on a wall of S. Bernardo, for the monks of Monte Oliveto, he made a S. Vincent, which is much esteemed by craftsmen. In a chapel at Sargiano, a seat of the Frati Zoccolanti di S. Francesco, without Arezzo, he painted a very beautiful Christ praying by night in the Garden.

In Perugia, also, he wrought many works that are still to be seen in that city; as, for example, a panel in distemper in the Church of the Nuns of S. Anthony of Padua, containing a Madonna with the Child in her lap, S. Francis, S. Elizabeth, S. John the Baptist, and S. Anthony of Padua. Above these is a most beautiful Annunciation, with an Angel that seems truly to have come out of Heaven; and, what is more, a row of columns diminishing in perspective, which is indeed beautiful. In the predella there are scenes with little figures, representing S. Anthony restoring a boy to life; S. Elizabeth saving a child that has fallen into a well; and S. Francis receiving the Stigmata. In S. Ciriaco at Ancona, on the altar of S. Giuseppe, he painted a most beautiful scene of the Marriage of Our Lady.

Piero, as it has been said, was a very zealous

student of art, and gave no little attention to perspective; and he had a very good knowledge of Euclid, insomuch that he understood all the best curves drawn in regular bodies better than any other geometrician, and the clearest elucidations of these matters that we have are from his hand. Now Maestro Luca dal Borgo, a friar of S. Francis, who wrote about the regular geometrical bodies, was his pupil; and when Piero, after having written many books, grew old and finally died, the said Maestro Luca, claiming the authorship of these books, had them printed as his own, for they had fallen into his hands after the death of Piero.

Piero was much given to making models in clay, on which he spread wet draperies with an infinity of folds, in order to make use of them for drawing.

A disciple of Piero was Lorentino d'Angelo of Arezzo, who made many pictures in Arezzo, imitating his manner, and completed those that Piero, overtaken by death, left unfinished. Near the S. Donatus that Piero wrought in the Madonna delle Grazie, Lorentino painted on fresco some stories of S. Donatus, with very many works in many other places both in that city and in the district, partly because he would never stay idle, and partly to assist his family, which was then very poor. In the said Church of the Grazie the same man painted a scene wherein Pope Sixtus IV, between the Cardinal of Mantua and Cardinal Piccolomini (who was afterwards Pope Pius III), is granting an indulgence to that place; in which scene Lorentino portrayed from the life, on their knees, Tommaso Marzi, Piero Traditi, Donato Rosselli, and Giuliano Nardi, all citizens of Arezzo and Wardens of Works for that building. In the hall of the Palazzo de' Priori, moreover, he portrayed from the life Cardinal Galeotto da Pietramala, Bishop Guglielmo degli Ubertini, and Messer Angelo Albergotti, Doctor of Laws; and he made many other works, which are scattered throughout that city.

It is said that once, when the Carnival was close at hand, the children of Lorentino kept beseeching him to kill a pig, as it is the custom to do in that district; and that, since he had not the means to buy one, they would say, 'What will you do about buying a pig, father, if you have no money?' To which Lorentino would answer, 'Some Saint will help us.' But when he had said this many times and the season was passing by without any pig appearing, they had lost hope, when at length there arrived a peasant from the Pieve a Quarto, who wished to have a S. Martin painted in fulfilment of a vow, but had no means of paying for the picture save a pig, which was worth five lire. This man, coming to Lorentino, told him that he wished to have the S. Martin painted, but that he had no means of payment save the pig. Whereupon they came to an agreement, and Lorentino painted the Saint, while the peasant brought him the pig and so the Saint provided the pig for the poor children of this painter.

Another disciple of Piero was Pietro da Castel della Pieve [Pietro Perugino], who painted an arch above S. Agostino, and S. Urban for the Nuns of S. Caterina in Arezzo, which has been thrown to the ground in rebuilding the church. His pupil, likewise, was Luca Signorelli of Cortona, who did him more honour than all the others.

Piero Borghese, whose pictures date about the year 1458, became blind through the attack of a catarrh at the age of sixty, and lived thus up to the eighty-sixth year of his life. He left very great possessions in the Borgo, with some houses that he had build himself, which were burnt and destroyed in the strife of factions in the year 1536. He was honourably buried by his fellow citizens in the principle church, which formerly belonged to the Order of Camaldoli, and is now the Vescovado. Piero's books are for the most part in the library of Frederick II, Duke of Urbino, and they are such that they have deservedly acquired for him the name of the best geometrician of his time.

E*xtracts from Jacob Burckhardt's* The Cicerone.

The influence of Squarcione soon spread into Tuscany by means of *Piero della Francesca*, from Borgo San Sepolcro, already named as the master of Signorelli. His frescoes are in the choir of S. Francesco at Arezzo (best light towards evening), representing the story of Constantine and of the

True Cross, show in the parts that are preserved such energy of character, such movement, and such luminous colour, that one completely forgets the want of a higher conception of the facts. A Magdalen, near the door of the sacresty in the Cathedral of Arezzo, is excellent, and in good preservation. A little St. Jerome in a landscape, Academy at Venice, is much injured. This interesting master must also be studied in his birthplace, where the Resurrection of Christ, a wall-painting in the Comunità, an altar-piece in the chapel of the hospital, and other things, are very remarkable. At Rimini (S. Francesco) the fresco of Sigismondo Pandolfo Malatesta kneeling before S. Sigismund. At Urbino (sacresty of the Cathedral) the precious miniature-like little picture of the Flagellation. In the Town Gallery as this place (taken from S. Chiara) an architectural picture, of the ideal kind, formerly much like in intarsiatura.

In the rest of Italy the separate pictures (not those merely introduced into wall paintings and church pictures) even of princes are rare. *Piero della Francesca's* double portrait, with the especially graceful and allegorical pictures at the back, in the Uffizii, No. 1300, might represent a contemporary tyrant and his wife [without doubt Federigo da Montefeltro, Duke of Urbino, and his wife Battista Sforza].

P. della Francesca gives heads in profile, with the sharpest and most exact modelling, which omits no warts or other detail, on a pretty landscape background.

*E*xtracts from *W. G. Waters'* Piero della Francesca.

CHAPTER IX
THE TREATISE ON PERSPECTIVE
Fra Luca Pacioli, one of the most distinguished mathematicians of the age and a fellow-townsman of Piero, has had the misfortune to incur the censure of Vasari, who wantonly, if not malevolently, accused him of having appropriated without acknowledgement Piero's discoveries in mathematics—"tutte le fatiche di quel buon vecchio"—and of having passed them off as his own in his "Somma di Aritmetica," which he published in 1494. Lanzi, in his "History of Italian Painting," has repeated this charge, but the reports given elsewhere of Fra Luca's character, and the invariably affectionate and enthusiastic tone of his remarks concerning Piero, all tend to discredit Vasari's statement. Moreover, Piero's proficiency as a geometrician was well known, and any theft of this kind would have certainly been detected at once; but no one before Vasari ever accused Fra Luca.

At the outset of his "Treatise on Perspective," Piero lets it be seen that he fully realizes the importance of his task, and that he proposes to elucidate his meaning by scientific treatment of the entire theory. He leaves design and colour aside, and deals with perspective alone. His method is simple and coherent, each problem being explained by those which have preceded it: he states the problem in a few words, and gives the solution by means of drawings and explanatory letters. In the first book he treats of his subject by the help of the figures commonly used in Geometry, that is, the point and the line and the level surface. In the second book he deals with regular figures, and in the third with irregular. He does not presuppose any knowledge of the vanishing point; he insists simply that the lines of a square surface if produced must converge, and sets forth that, if the back line of such a surface be drawn parallel with the figure plane, it becomes an easy matter to determine the correct perspective of this surface; for, the extreme points being fixed, diagonal lines may be drawn through it, and any point within its limits correctly located. Also, if this same flat surface be set upright, all the vertical points therein may be determined in like manner. By this simple and ingenious process Piero formulates and establishes a rule for the solution of the elementary difficulties of perspective.

Piero really took up Alberti's teaching, which was based not so much on general principles as on geometrical and optical experiments, and carried on the science of perspective to the point at which it remained for several centuries, until the theory of the vanishing point was finally established. Baldassare Peruzzi was a diligent student of the "Prospettiva," and wrote several commen-

taries on it, and, together with Daniele Bartolo, Romano Alberti, and divers others, has left his testimony to Piero's merits as a geometrician.

Piero's other work, the "Libellus de quinque corporibus regularibus" is a treatise on the practical application of Euclid's propositions to the needs of Art, which propositions, up to his time, could only be worked out by roundabout methods. The five bodies in question are the triangle with four bases, the cube with six faces, the octohedron with eight faces and as many triangles, the dodecahedron with twelve faces and as many pentagons, and the icosahedron with twenty faces and as many triangles.

Piero dedicates this treatise to Duke Guidobaldo of Urbino, and writes as follows: "And as my works owe whatever illustration they possess solely to the brilliant star of your excellent father, the most bright and dazzling orb of our age, it seemed not unbecoming that I should dedicate to your Majesty this little work on the five regular bodies in mathematics which I have composed, that, in this extreme fraction of my age, my mind might not become torpidly inactive. Thus may your splendour reflect a light upon its obscurity, and Your Highness will not spurn these feeble and worthless fruits gathered from a field now left fallow, and nearly exhausted by age, from which your distinguished father has drawn its better produce, but will place this is some corner as a humble handmaid to the numberless books of your own and his copious library near our other treatise on perspective which we wrote in former years."

These words must have been written after Guidobaldo's accession in 1482, and they go to prove that Piero was active and in full enjoyment of his faculties in old age. They give, moreover, a pleasant glimpse of the kindly feeling subsisting between the accomplished young prince and the illustrious artist and man of science, and show that Piero's relations with the son were as cordial as they had been with the father. Piero left the MS of this work in the library at Urbino, from whence it was carried off to Rome during the usurpation of Caesar Borgia.

Of the latter portion of Piero's life scarcely anything is known. He seems to have been at Borgo San Sepolcro in 1469, the year when he signed the receipt for the balance due for the altar-piece in the church of Sant'Agostino, which he had begun in 1454; and then, until 1478, there is a complete blank. In 1478 the Compagnia della Misericordia at Borgo gave him a commission to paint the fresco already referred to, which Vasari mentions and which has now perished. On July 5th, 1487, he made his will, and on October 12th, 1492, he died and was buried in the church of the Badia—now the cathedral—at Borgo San Sepolcro.

Vasari's remark that Piero become blind in his old age may reasonably be added to the list of his mis-statements. Arguments against its validity are not far to seek. Fra Luca, who never loses an opportunity of recording facts about his master, is entirely silent on this point; and it is hard to believe that a fact so salient would have been unnoticed by him. If dates are compared, fresh proof will appear. Vasari gives Piero's age at his death as eighty-six. The records at Borgo fix his death accurately as occurring in 1492; wherefore, if all these figures are correct, he must have been born in the year 1406, and have lost his sight in 1466, a year when he was actively engaged in painting at Borgo and at Arezzo, and three years before his summons to Urbino, where he painted some of his most delicately finished work. Moreover, Vasari records that he executed the *Misericordia* fresco at Borgo San Sepolcro, a work which is known to have been painted after 1478. An expression in his will, which he made in 1487, describing himself as "sanus mente intellectu et corpore," is hardly one which a blind man would have used or permitted; and, as a final contradiction to Vasari's statement, it may be noted that Piero was able to dedicate his work, "Libellus de quinque corporibus regularibus" to Duke Guidobaldo of Urbino, who had succeeded to his inheritance as late as 1482.

CHAPTER X

THE CHARM OF PIERO—HIS PLACE IN ART

At the time of Piero's birth the prevailing art influence throughout Central Italy was unquestionably Sienese. At Orvieto Simone Martini had painted his

remarkable picture of the *Virgin and Saints* for the church of San Domenico, and had left other work of his to stand beside Giotto's at Assisi, where also Pietro Lorenzetti had covered with frescoes the roofs of several of the transepts. At Città di Castello this same Lorenzetti painted a *Virgin and Child with Angels* for the church of San Domenico; at Arezzo in Santa Maria della Pieve a polyptych of *Madonna and Saints*; and at Cortona a *Madonna and Angels* in the Duomo, and a crucifix in the church of San Marco. At Asciano Domenico di Bartolo, Lippo Memmi, and Taddeo di Bartoli painted altar-pieces in several of the churches and at Perugia Piero might well have seen and studied pictures by Duccio, Domenico di Bartolo, Taddeo di Bartoli, and Gentile da Fabriano, while at Gubbio Ottaviano Nelli had decorated with frescoes the church of Santa Maria Novella and several others.

Thus the principal pictorial creations which were brought before the eyes of Piero as a youth in the towns adjacent to his birthplace were for the most part produced by men in whom the primitive inspiration had been modified, and the faculty of representation helped onward by the peculiar qualities of Sienese teaching. These men held the field in his youth, but a farther and more momentous period of advance was at hand. Their traditions and method waned before those which followed the rise of Masaccio, and the manifestation of Donatello's powers: events which gave to art the most effective impulse it had yet received, and made their influence felt far and wide. Andrea dal Castagno and Domenico Veneziano were the earliest and most illustrious of those who took up the new teaching; so, when Piero was old enough to learn, he went for training and inspiration to the works of men who had formed their style by a study of Masaccio and Donatello, and found himself urged on towards the adoption of the new traditions before his method had become fixed on conventional lines. In brief retrospect it may be noted that the central Italian school of painting, after the primal momentum given to it by the two great contemporary masters, Duccio and Giotto, was forced onward by successive manifestations of the art spirit issuing respectively from Siena and Florence. In the beginning Giotto unquestionably held the field against his great compeer, but after his death came that Sienese movement, which by its feeling for beauty of line subdued the austerity of Giotto's style. Then came the second great Florentine outburst which under Masaccio's direction, launched the art of painting in the course it has pursued with slight variation ever since. It was a happy conjunction when Piero was born into a world which was just opening its eyes to the new light.

It is possible that too great importance has been attached to Piero's achievements on the scientific side of art. No claim which aims at marking him as the discoverer of perspective can be seriously entertained; but his eulogists, though they stop short of this, affirm that Paolo Uccello and Brunelleschi were little better than perspectivists by rule of thumb, and that Piero it was who first raised perspective to the dignity of a science, and that no one before his time had ever duly applied it to the delineation of the human form. There is a certain ground for this claim, but its validation is of little importance in settling thee question of his place in the hierarchy of art. He undoubtedly drew his figures with more knowledge than Masaccio, but it would be rash to assert that he always drew them with greater grace or accuracy.

Piero had an important share in bringing to perfection the medium of painting. He adopted the method which Antonello da Messina is said to have learnt from some Flemish master,[1] and expended great care and trouble in patient experiments for its improvement. He painted his lights with clear colour, using the same tint somewhat darkened for the shadows. The medium tints are always cool and reticent, and the flesh tones warmed with a due amount of colour. The delicacy of chiaroscuro which he achieved was largely the result of fine and transparent glazings, and few painters in any age have excelled him in the faculty of illumination of flesh tints.[2] When he set to work to paint drapery he began fearlessly with a scheme of primitive colours which he toned down gradually to a just balance of values, so that the general effect might ultimately be one of complete harmony.

In the distribution of light and shade he displayed a knowledge and dexterity which were equally remarkable. Seldom or ever does he concentrate the light in one point of his picture; he rather treats each field of illumination by itself, and gives to each tint its proper local depth within the plane of the group or scene portrayed—notable examples of this characteristic being the two smaller frescoes above the *Victory of Constantine* in San Francesco at Arezzo. A particular study of chiaroscuro indeed may be found in almost any portion of any picture from his brush. In this respect his method finds its direct contrary in that of Rembrandt, who in his typical works depends for effect upon the condensation of all his light upon one single spot, an illuminated point in a firmament of obscure canvas.

It is in the drawing of architectural accessories that Piero shows the most marked superiority to his predecessors and contemporaries, but this result probably arose from the fact that he attached greater importance to these accessories, and deemed them worthy of the best work he could give. It is not safe to assume that the painter before the revival ignored landscape and the beauty of the human form, or gave to the same an uncomely or amorphous rendering through mere incapacity. They treated with neglect subjects like these, or slurred them over, because, infected with cloistral influences, they deemed them worthy of no better usage. Nature and man himself were accounted worthless, or even noxious, as themes for illustration. They still seemed to suggest something of the pagan spirit in Art which the early Christians had exorcised as unclean, when they demolished the temples and broke the images of the gods; but had these themes, as details, appeared as important to the primitive painters as geometrical perspective appeared to Piero, it is probable that even the earliest and most ascetic of them would have worked with care and diligence, and perchance have produced bits of nature as charming as those which adorn the backgrounds of Perugino or Titian himself.

The longer and the more attentively Piero's work is studied, the plainer it will be manifest that the cause of the peculiar charm which he exercises— a charm which compels the respect even of those who carp at a tendency, as they allege, to ignore the claims of beauty of form and expression—does not lie merely in his technical excellence, or in his wide knowledge of his art. This charm begins to operate as soon as the onlooker realizes in Piero the possessor of a certain mysterious power, a power denied to crowds of men who have equalled or even surpassed him in excellence of workmanship. This power was the gift which made him the great man ha was, and to speculate as to its source would be labour in vain. One instance, perhaps, may be quoted to show how vast may be the loss consequent on its absence—to wit, the instance of Correggio. Correggio had talents of the first order, a marvelous sense of beauty and sureness of execution, but with all these gifts his works miss the point of consummate achievement, and do not leave on the mind an impression at all commensurate with that which Piero's creations seldom fail to produce upon those who have studied them with care and intelligence.

The portrait fresco of Sigismondo Pandolfo Malatesta at Rimini—though it cannot be regarded as Piero's most attractive work—is second to none as an illustration of his peculiar gift. In the description of the picture already given, reference was made to the wonderful restraint displayed by Piero in treatment, and to the marvellous result attained. In this creation, more than in any other, Piero, by the application of his well-trained hand and his well-stored mind to the precious gifts bestowed on him by nature, has produced a work which, as a manifestation of absolute sincerity and originality of treatment, is equalled by few extant examples of the portrait art. Not one superfluous stroke has been used in presenting the subject: and in spite of this reticence it is possible to stand before this fresco without realizing, albeit imperfectly, the immense power of the intellect which produced it.

Piero's nature was one of those richly endowed ones which the fifteenth century produced in such rare abundance: a nature which, realizing to the full the real significance of art, gave itself up wholly to the fulfilment of its mission, and found its fellows in the immortal personalities of Brunelleschi, Leo

171

Battista Alberti, and Leonardo. Piero, indeed, was lacking in the versatility of these: but, if his field was somewhat narrow, his vision was as clear as theirs, and no artist ever set to work with a more certain notion of the task to be accomplished. And he did not spare himself. Painting, as he found it, lacked the precision and sureness of touch which he regarded as essential. It must not be supposed that he studied geometry for its own sake: he troubled himself with it simply because in it he recognized the most efficient instrument for bringing his art to perfection.

In literature and in art as well, the student will light upon figures which, if for no other reason, compel attention from the fact that they stand apart, upon pedestals of their own. Piero della Francesca is one of those great solitary figures in the world of Art, and there are not many of them. To take Duccio, Giotto, and all the masters of the Sienese and Florentine schools down to the time of Masaccio; all of these borrowed from their forerunners (Duccio from the Byzantines), and handed down a legacy of form and colour to their successors, thus producing a sequence of pictorial examples which all show signs of descent from the first recognized progenitor of the line, modified here and there by the more potent individuality of some transmitter of the legend. Amongst the Florentines, the Lombards, the Venetians, and the Central Italians after the revival, a similar phenomenon is to be observed, but Piero more than any master of any of the schools aforesaid stands aloof.

We are taught that certain men were his masters, and that the work of certain other painters helped to form his style. It is not difficult to detect in the *Virgin Enthroned*, and in the two heads of saints in the National Gallery by Domenico Veneziano, traces of the informing spirit which affected the beginning of Piero's method. The noble simplicity of Domenico's figures, the dignified reticence of the faces (Donatello's influence is here plainly manifest) and the carefully drawn and richly painted draperies of these compositions are all reproduced in the subsequent work of his greatest pupil. The striving after correct drawing, which is apparent in the lines of the marble chair occupied by the Virgin in the National Gallery picture, shows that Domenico had at least the sense of perspective, though the mistakes, which must affront even the eye of a novice, prove that he was still in the empiric stage.

Domenico's most marked characteristic is the grandeur of his conception of the human form, and the supremacy he gives to it in the scheme of his compositions. In the London *Madonna*, signs of the influence of Angelico are apparent; but these grow less in the *Virgin and Saints* in the Uffizi, and in the fresco figures of two saints in Santa Croce[3] they disappear entirely. Domenico felt and manifested freely the spirit of the revival; he lived in the full vigour of the early spring, and handed on to his pupil a virtue which was yet waxing and unfolding. To judge a right of work executed in this era of spontaneous vigour, it is only necessary to place it beside some product of an age of stagnancy or decay, some smooth, showy canvas of the mannerist period, the result of eyesight sated by the contemplation of pictorial achievement of all degrees of merit, and too weary and too imperfectly disciplined to return to nature.

Andrea Castagno, Domenico's contemporary, is often cited as one of those whose work and teaching helped to form Piero's style, and this contention is just. Castagno had the gift of letting his figures stand firmly on their feet and in perfect balance, a gift which he handed on to Piero. Piero's figures, even in his early works, are posed with dignity and certitude; and no figures of his are more reminiscent of Castagno's handling than the Sant'Andera and the San Sebastian in the *Misericordia* altar-piece at San Sepolcro.

An examination of Andrea's fresco of the *Resurrection* at Sant'Apollonia in Florence will show another instance. The figure of Christ standing upon the edge of the tomb, the cold clear sky of morning, and the background of trees might well have been in Piero's mind when he conceived the scheme of his fresco of the same subject at Borgo San Sepolcro; while many others of his figures are strongly reminiscent of the drawings of sibyls and warriors by Castagno, which have been brought to Sant'Apollonia from the Villa Legnaia, near Florence. Judging from the stately usage Piero followed in

posing his figures, in may be inferred with reason that he also felt directly Donatello's influence during his student life at Florence as Domenico's pupil. Possibly the spectacle of certain treasures of classical antiquity may have affected him as well; but in his case classical influences were far less potent than they were in that of Mantegna. Finally, during his career as a student, he must frequently have come across the work of Fra Angelico and Benozzo Gozzoli; but whether he studied them or not, they assuredly left no trace on his style, which finally emerged entirely free from the superficiality of Gozzoli, and from the monkish restraint of Angelico.

[1] Piero almost certainly studied the use of oil as a medium while painting with Domenico Veneziano at Florence: some years before Antonello was born, Cennini writes that the Florentine painters of the fourteenth century knew of the use of oil.

[2] In certain of his pictures—notably in the faces of the angels in the *Baptism* in the National Gallery—the underlying impasto seems to have suffered some change which has affected the modelling.

[3] This work was until recently attributed to Castagno.

*A*n excerpt from Clive Bell's Art.

THE AESTHETIC HYPOTHESIS

What quality is common to Sta. Sophia and the windows at Chartres, Mexican sculpture, a Persian bowl, Chinese carpets, Giotto's frescoes at Padua, and the masterpieces of Poussin, Piero della Francesca, and Cézanne? Only one answer seems possible—significant form. In each, lines and colours combined in a particular way, certain forms and relations of forms, stir our aesthetic emotions. These relations and combinations of lines and colours, these aesthetically moving forms, I call 'Significant Form" and 'Significant Form' is the one quality common to all works of visual art.

The hypothesis that significant form is the essential quality in a work of art has at least one merit denied to many more famous and more striking—it does help to explain things. We are all familiar with pictures that interest us and excite our admiration, but do not move us as works of art. To this class belongs what I call 'Descriptive Painting'—that it, painting in which forms are used not as objects of emotion, but as means of suggesting emotion or conveying information. Portraits of psychological and historical value, topographical works, pictures that tell stories and suggest situations, illustrations of all sorts, belong to this class. That we all recognize the distinction is clear, for who has not said that such and such a drawing was excellent as illustration, but as a work of art worthless? Of course many descriptive pictures possess, amongst other qualities, formal significance, and are therefore works of art: but many more do not. They interest us; they may move us too in a hundred different ways, but they do not move us aesthetically. According to my hypothesis they are not works of art. They leave untouched our aesthetic emotions because it is not their forms but the ideas or information suggested or conveyed by their forms that affect us….

Most people who care much about art find that of the work that moves them the most the greater part is what scholars call 'Primitive'. Of course there are bad primitives… but such exceptions are rare. As a rule primitive art is good—and here again my hypothesis is helpful—for, as a rule, it is also free from descriptive qualities. In primitive art you will find no accurate representation; you will find only significant form. Yet no other art moves us so profoundly….

Naturally, it is said that if there is little representation and less saltimbancery in primitive art, that is because the primitives were unable to catch a likeness or to cut intellectual capers. The contention is beside the point. There is truth in it, no doubt, though, were I a critic whose reputation depended on a power of impressing the public with a semblance of knowledge, I should be more cautious about urging it than such people generally are. For to suppose that the Byzantine masters wanted skill, or could not have created an illusion had they wished to do so, seems to imply ignorance of the amazingly dexterous realism of the notoriously bad works of that age. Very often, I fear, the misrepresentation of

the primitives must be attributed to what the critics call, 'willful distortion'. Be that as it may, the point is that, either from want of skill or want of will, primitives neither create illusions, not make display of extravagant accomplishment, but concentrate their energies on the one thing needful—the creation of form. Thus they have created the finest works of art that we possess.

Let no one imagine that representation is bad in itself; a realistic form may be as significant, in its place as part of the design, as an abstract. But if a representative form has value, it is as form, not as representation. The representative element in a work of art may or may not be harmful; always it is irrelevant. For, to appreciate a work of art we need bring with us nothing from life, no knowledge of its ideas and affairs, no familiarity with its emotions. Art transports us from the world of man's activity to a world of aesthetic exaltation. For a moment we are shut off from human interests; our anticipations and memories are arrested; we are lifted above the stream of life….

Significant form stands charged with the power to provoke aesthetic emotion in anyone capable of feeling it. The ideas of men go buzz and die like gnats; men change their institutions and their customs as they change their coats; the intellectual triumphs of one age are the follies of another; only great art remains stable and unobscure. Great art remains stable and unobscure because the feelings that it awakens are independent of time and place, because its kingdom is not of this world. To those who have and hold a sense of significance of form what does it matter whether the forms that move them were created in Paris the day before yesterday or in Babylon fifty centuries ago? The forms of art are inexhaustible; but all lead by the same road of aesthetic emotion to the same world of aesthetic ecstasy.

Concise Bibliography

Baxandall, M. *Patterns of Intention of the Historical Explanation in Pictures*. New Haven: Yale University Press, 1985

Beck, James H. *Italian Renaissance Painting*. Cologne: Könemann Verlagsgesellschaft, 1999.

Berenson, Bernard. *The Central Italian Painters of the Renaissance*. London: Chapman & Hall, 1897.

Bertelli, Carlo. *Piero della Francesca: The Frescoes of San Francesco in Arezzo*. Milan: Skira, 2002.

Burckhardt, Jacob. *The Cicerone*. London: John Murray, 1873.

Calvesi, Maurizio. *Piero della Francesca*. New York: Rizzoli International Publications, 1998.

Crow, J. A. and G. B. Cavalcaselle. *A History of Painting in Italy from the Second to the Sixteenth Century*. London, 1866.

Field, J. V. *The Invention of Infinity: Mathematics and Art in the Renaissance*. London, 1997.

Ginzburg, Carlo. *The Enigma of Piero della Francesca*. London: Verso, 2002.

Lavin, M. Aronberg. *Piero della Francesca: The Flagellation*. New Haven: Yale University Press, 1981.

Longhi, Roberto. *Piero della Francesca*. Riverdale-on-Hudson: Sheep Meadow Press, 2002.

Pope-Hennessey, J. *The Piero della Francesca Trail*. London, 1991.

Vasari, Giorgio. *Lives of the Painters, Sculptors, and Architects (2 Volumes)*. London: David Campbell Publishers, 1996.

Waters, W. G. *Piero della Francesca*. London: G. Bell and Sons, 1901.